Andrei Tarkovsky:
Ivan's Childhood

KinoSputnik 4

KinoSputniks

Series Editor: Birgit Beumers

Editorial Board: Richard Taylor, Julian Graffy and Denise Youngblood,

This series aims to provide concise companion guides to some of the key films to emerge from Russian, Soviet and post-Soviet cinema from its inception to the present day. Continuing from KinoFiles (2000–10), the KinoSputniks are aimed at film enthusiasts and students alike, combining scholarship with a style of writing that is accessible to a broad readership. Each KinoSputnik is written by a specialist in the field of Russian and/or film studies, and examines the production, context and reception of the film, whilst defining the film's place in its national context and in the history of world cinema.

Current titles:

Andrei Tarkovsky:
Ivan's Childhood

By Robert Efird

intellect

Bristol, UK / Chicago, USA

First published in the UK in 2022 by
Intellect, The Mill, Parnall Road, Fishponds, Bristol, BS16 3JG, UK

First published in the USA in 2022 by
Intellect, The University of Chicago Press, 1427 E. 60th Street, Chicago,
IL 60637, USA

A catalogue record for this book is available from the British Library.

Copy editor: MPS Limited
Cover designer: Aleksandra Szumlas
Production manager: Sophia Munyengeterwa
Typesetting: MPS Limited

Print ISBN: 978-1-78938-478-9
ePDF ISBN: 978-1-78938-477-2
ePUB ISBN: 978-1-78938-479-6

Part of the KinoSputniks series
ISSN 2059-5069 | Online ISSN 2059-5077

Printed and bound by CMP

To find out about all our publications, please visit

www.intellectbooks.com.

There, you can subscribe to our e-newsletter,
browse or download our current catalogue,
and buy any titles that are in print.

This is a peer-reviewed publication.

Contents

Illustrations

Note on Transliteration

The Library of Congress (ALA-LC) system has been used throughout. Exceptions have been made when a Russian name has an accepted English spelling (e.g. Chaliapin instead of Shaliapin; Eisenstein instead of Eizenshtein); and we have opted for the commonly used spelling of Tarkovsky and Konchalovsky (instead of Tarkovskii and Konchalovskii). The spelling of the film studios (Mosfilm, Lenfilm) omits the soft sign, as per common usage.

All translations are my own.

Acknowledgements

I am extremely grateful to the staff at Intellect for making this book possible and would especially like to thank Birgit Beumers for her understanding and encouragement with the project. Completing it in the midst of the COVID-19 pandemic proved more difficult than I had anticipated and the help she provided (which, at first, I foolishly ignored) proved invaluable, as did her comments and suggestions. I am also thankful to my colleagues Alexander Dickow and Yulia Minkova, who at various stages generously lent their time to these pages. A special note of gratitude also goes to Dodona Kiziria, who first showed me this film many years ago in graduate school. In the last stages of this writing, I was particularly reliant on the patience and support of Amy Baldwin, as well as the recreational distractions provided by my sons, Andrew and James. Finally, I need to give special recognition to my mother Joan, who proofread, offered suggestions and even said she would watch the movie. It is to her this book is dedicated.

Production Information

Production credits
Russian title: *Ivanovo detstvo*
US title: *My Name is Ivan*
Director: Andrei Tarkovsky
Screenplay: Mikhail Papava and Vladimir
 Bogomolov
Cinematography: Vadim Iusov
Production design: Evgenii Cherniaev
Editor: Liudmila Feiginova
Music: Viacheslav Ovchinnikov
Producer: Gleb Kuznetsov
Production company: Mosfilm
Release Date: 6 April 1962
US Release Date: 27 June 1963

Cast
Ivan: Nikolai Burliaev
Lieutenant Gal'tsev: Evgenii Zharikov
Captain Kholin: Valentin Zubkov
Katasonych: Stepan Krylov
Masha: Valentina Maliavina
Colonel Griaznov: Nikolai Grin'ko
Ivan's mother: Irma Rausch [Raush]

Soldier with glasses: Andrei Konchalovsky
Little girl: Vera Miturich
Old man: Dmitrii Miliutenko
Soldier: Vladimir Marenkov
Soldier: Ivan Savkin

Plot Summary

A boy stands next to a birch tree and looks through a spider's web as a cuckoo echoes over the soundtrack. Moving through the summer landscape, he begins to laugh and levitate through the trees. Descending along the slope of a hill, the boy finds himself inspecting the roots of a tree and then runs to his mother, who places a bucket of water on the ground for him to drink. As he begins to tell her about the cuckoo, a crash rings out and the boy screams. Waking violently from this dream, he methodically makes his way from the windmill where he slept and over a dark hill littered with bodies and wrecked machinery. The credits roll as he makes his way to the edge of a swamp and crosses a river.

Lieutenant Gal'tsev is shaken awake by a sentry, who informs him they have detained the child. As the sentry leaves, the boy gives his name as Bondarev and demands to be put in immediate contact with Colonel Griaznov and Captain Kholin. His credentials eventually established, Ivan is given space to work, a bath and a meal, which he all but ignores. Carried to bed by Gal'tsev, another dream begins, which takes place at the mouth of a well. Looking down into the water with his mother, Ivan attempts to grasp a star and somehow appears at the bottom. German is heard on the soundtrack, shots ring out and a bucket falls.

The boy again calls out for his mother, whose motion-less body lies beside the well.

As he awakes Ivan confesses a case of frayed nerves to Gal'tsev when Kholin unexpectedly enters and calls out to him. Shortly after their happy reun-ion, the scene shifts to Griaznov and Katasonych, who has spent the night waiting in vain for Ivan on the other side of the river. Ivan bursts in, chased by Kholin, and demands that he remain at the front rather than be sent to a military school away from the action.

Having fled the Soviet camp, Ivan meets up with an elderly, shell-shocked peasant sifting through the remains of his hut (*izba*) in expectation of his dead wife. Ivan's attempts to help him are interrupted by the arrival of Griaznov, Kholin and Katasonych, who transport him back to the base. Despite Ivan's pro-tests, Griaznov reiterates his intention to send him to the rear.

Gal'tsev criticizes the work of a young medical officer when Kholin enters to make an inspection of the fortifications. Kholin and the young woman, Masha, are then shown alone together in a forest. An oddly tense and awkward romantic exchange culmi-nates with Kholin kissing her as he holds her over a trench and then telling her to leave. As she runs off through the forest, Gal'tsev appears on the scene; the inspection alluded to in the previous sequence fol-lows. Gal'tsev infers from the discussions that Ivan will again be doing reconnaissance work. As they exit

the trench the soldiers pass by Masha, who has been approached by another young soldier. She waltzes alone through the woods and her perspective shifts to the bodies of two other scouts (seen a few moments earlier when Kholin looked through a periscope in the trench) displayed by the Germans on the other side of the river.

Ivan and Katasonych meet Kholin and Gal'tsev in the latter's quarters. Kholin and Katasonych discuss plans for the upcoming mission while repairing a phonograph. Ivan looks over a captured collection of Albrecht Dürer's engravings while Gal'tsev listens in on the other conversation. As the three adults leave to inspect the boats Gal'tsev has hidden at the edge of the river, he lends Ivan a knife that belonged to a fallen comrade. At the riverbank, the three argue over Ivan's past and future while the boy, left alone, begins an imaginary pursuit of a German officer. The game becomes a frightening hallucination with spectral voices and figures. Ivan imagines victory but collapses into tears when confronting the officer of his imagination. The onset of German shelling thunders outside and sunlight breaks into the darkened chapel.

Gal'tsev has run back to check on Ivan and as the two straighten up the room they argue over the military school. Presumably that same evening, Kholin enters for a meal and announces that Katasonych has been called away and Gal'tsev will be going instead. Ivan falls to sleep and experiences a surreal dream of himself in the back of a truck with an unidentified

young girl. The dream ends with the truck spilling its load of apples for horses on a beach and Ivan opens his eyes to Kholin awakening him for the mission.

After crossing the river and wading to the shore, the men bid farewell to Ivan, who disappears in the swamp. Kholin sneaks off to retrieve the bodies of the two scouts seen earlier. The men are fired upon as they return to the Russian side and forced to swim alongside their boat. Resting back in Gal'tsev's quarters, they listen to a recording of Feodor Chaliapin on the repaired phonograph and Masha enters to say goodbye. The record skips and Kholin angrily throws a stool. Documentary images of soldiers celebrating the Soviet victory in Berlin become images of death and destruction, including gruesome footage of murdered children. Back within the story, Gal'tsev appears in one of the ruined buildings as his men sift through Gestapo files. Spying the dossier on Ivan, Gal'tsev experiences his own hallucinatory reverie as he moves through the building and into the execution chamber.

From documentary footage of gallows and a guillotine, Ivan rolls across the floor and his beaten face looks up at his smiling mother, an echo of the film's opening sequence. She departs and Ivan plays hide and seek with a group of children on the beach, including the young girl from the previous dream. The two of them run out onto a sandbar. As Ivan moves further into the water the camera reverses back up the beach and rushes into the trunk of a dead tree.

Introduction

The premiere of *Ivan's Childhood* (*Ivanovo detstvo*) in 1962 marked a critical moment in the history of Russian cinema. Although it appeared towards the end of the political and cultural Thaw (roughly 1956–64) that followed the death of Stalin, the film nevertheless revealed an intensely new creative dimension in Soviet art; that is to say, art produced in the Soviet Union. Following the Stalinist period, cracks began to form in the transparent propaganda that characterized so much of Soviet cinema, occasionally giving way to works that dealt less with towing the party line and more with personal and individual experiences. Yet even during this period of relative freedom and experimentation, this film's raw emotional turns, fractured presentation of reality and deep exploration into the intimate trauma of war were seen as ground-breaking moves. Though it took root in the stylistic and thematic experimentations of filmmakers like Mikhail Kalatozov and Grigorii Chukhrai, the originality of *Ivan's Childhood* immediately made it an exemplar to the burgeoning 'poetic' school of Soviet cinema and an inspiration to directors like Sergei Parajanov and Otar Ioseliani. In the West, it was the first Soviet film to win the Golden Lion at the

Venice Film Festival (sharing the Prize with Valerio Zurlini's *Cronaca familiare* [*Family Diary*]) and it elicited emphatic praise from luminaries like Ingmar Bergman and Jean-Paul Sartre, with the latter even writing an impassioned defence of the film in response to a surprisingly negative (and poorly considered) review from the Italian communist newspaper *L'Unita*. In remarkably short order, *Ivan's Childhood* had become one of the most important films ever produced in the Soviet Union, and its director, Andrei Tarkovsky, a strikingly vital force in world cinema.

Today, despite the sensation of its initial appearance, much of the film's significance appears to stem from the fact that it is the first truly professional effort of the most important Russian film-maker since Sergei Eisenstein, and not its undeniable status as a seminal work of the 1960s. Now regarded as one of the most significant Russian artists of the twentieth century, Andrei Tarkovsky was then only a recent graduate of the All-Union State Institute of Cinematography (Vsesoiuznyi Gosudarstvennyi Institut Kinematografii, VGIK), with limited experience making a film on his own. The instant renown brought by the film's success at home and abroad opened the doors to larger, more experimental works like *Andrei Rublev* (1966) and *Zerkalo* (*Mirror,* 1975) which, while they pushed the director further outside the Soviet mainstream, also cemented his place in the Russian cultural pantheon. Against the complexity and occasional opacity of these later films, *Ivan's Childhood* is easily the

most accessible of Tarkovsky's seven features and an invaluable primer to a body of work that has influenced philosophers and artists for decades. But it is much more than just an introduction; for all of its relative clarity and polyvalent appeal, there is nothing simple about this film.

From the very first frames, it is clear that this is not an ordinary war story. Intricate compositions and details emerge unceasingly as the story progresses, as do inconspicuous visual and aural arrangements easily missed on an initial viewing. On the surface, one may appreciate *Ivan's Childhood* simply for the depth of its plot. In many ways, Tarkovsky's adaptation (2003) clings tightly to Vladimir Bogomolov's novella 'Ivan' (1957) – the stark, yet penetrating account of a 12-year-old orphan serving as a scout for the Red Army in the darkest days of the Second World War. But from this matrix, the film also fashions an ever-expanding web of seemingly divergent images and sounds, which gradually coalesce into some of the most emotionally bracing moments ever seen on Soviet screens. Definitive lines are established between the Russians and Germans, dream and reality, life and death, only to be transgressed and ultimately erased as the story progresses. All the while, the film-maker manipulates the technical aspects of the medium in tight correlation with the development of the plot. *Ivan's Childhood* displays a masterfully executed fusion of form and content as editing, camera angles and even the

overarching structure of the narrative come to function as integrated aspects of the story. As such, the film offers a challenging, though rarely daunting, role to the audience: we are encouraged to devote attention to narrative subjectivity, respond to visual and aural rhymes, and re-evaluate our own notions of time, memory and reality as we, along with the other characters of the film, piece together the splinters of the child soldier's life.

Soviet war films

The Second World War, with the astronomical casualties and wholesale destruction endured in the Soviet Union (and sometimes forgotten in the West), has saturated Russian cinema and art from the first days of the Nazi invasion in 1941. Even amidst the chaos, while German soldiers stood on Soviet soil, evacuated studios were producing films devoted to the struggles of both soldiers and ordinary citizens against the invaders. In the decades since, the catastrophic impact of the war has continued to resonate. Following the death of Stalin, many of the definitive films of the Thaw, such as Mikhail Kalatozov's *Letiat zhuravli* (*The Cranes Are Flying*, 1957), Grigorii Chukhrai's *Ballada o soldate* (*Ballad of a Soldier*, 1959), and Sergei Bondarchuk's *Sud'ba cheloveka* (*Fate of a Man*, 1959) were set in the midst of the conflict and offered distinctive new perspectives on the war itself and the place of the individual. In fact, the historian Denise J. Youngblood has found that this dramatic shift in tone

was, in itself, 'a key aspect of de-Stalinization' (2007: 11). With the increasing sacralization of the conflict, and despite the tightening of central controls, the Brezhnev years continued the re-examinations of the war with the appearance of truly remarkable films like Aleksei German's *Proverka na dorogakh* (*Trial on the Road*, 1971, released 1987) and Larisa Shepit'ko's *Voskhozhdenie* (*The Ascent*, 1977). Even with the waning quantity and influence of cinema in the perestroika period, the war stayed in nearly constant focus; the disintegration of the Soviet Union brought with it new ways of understanding the enemy, but in no way extinguished the collective fascination with what remains a national trauma. More than 70 years after the fall of Berlin, the Russian film and television industry (often with the explicit encouragement of the government) continues to develop provocative ways of depicting the struggle.

Among the hundreds of works that take on the theme, *Ivan's Childhood* is at once comfortably familiar and astonishingly unique. The depiction of children and adolescents fighting to survive the worst years of the twentieth century finds a place in most Soviet war films. From the pinnacle of Soviet martyrdom, Zoia Kosmodemianskaia in Lev Arnshtam's *Zoia* (1944), through the harrowing experience of Floria in Elem Klimov's *Idi i smotri* (*Come and See*, 1985), stories that take the fate of children and young people at war as a central theme constitute a distinct subgenre of Soviet cinema. This was particularly so

5

during the Stalin years, as melodramatic boilerplate like Viktor Eisymont's *Zhila byla devochka* (*Once There was a Girl*, 1945), a sanitized depiction of two children enduring the siege of Leningrad, Vasilii Pronin's jingoistic *Syn polka* (*Son of the Regiment*, 1946), and the aforementioned *Zoia,* a classic Soviet tale of self-sacrifice before cartoonishly evil invaders, provided children and adults alike with examples of heroism and civic devotion. Such films peaked later in the Stalin era with Sergei Gerasimov's *Molodaia gvardiia* (*Young Guard*, 1949), but the plight of the child or teenager at war has never disappeared from Russian screens.[1]

By the late 1950s and early 1960s, the characters populating Soviet cinema had become increasingly complicated - far from the clichéd caricatures of the Stalin era - as internal struggles, personal failings, and moral ambiguity rose to the surface in the wake of relaxing central controls. Yet even here, with the ubiquitous focus on the war and the prominent place of children on Soviet screens, Ivan is something of a rarity. As Josephine Woll described it, the director 'combined and revised multiple thematic elements characteristic of the Thaw in *Ivan's Childhood* - the child at its centre, the surrogate parenting, the primacy of emotions' (2000: 143). But at the same time, she contends, the film 'skews one commonplace of Thaw art, the innocent child hero' (Woll 2000: 140). This is not entirely due to the film-maker; even in Bogomolov's rather flat characterization of the boy,

there is an element of precocious malevolence far beyond that of the typical child fighter. Tarkovsky remarked in his book *Sculpting in Time* (1986) that he was attracted most by what this tragic figure had lost, how the sacred innocence of his life had been twisted by the war into something almost unrecognizable and evil.

But while he could be an astute commentator on his own work, what actually emerges in the film is slightly different. Ivan, at least when compared with the boy we see in his dreams, has indeed been poisoned by the war. As these sequences reveal, perhaps the most tragic aspect of the film is that despite the twisted exterior he is still very much a child. Driven by an obsessive, even pathological desire for revenge, he still clings desperately to the remains of an innocence prematurely shattered. Working from this dichotomy, Tarkovsky expands the relative simplicity of Bogomolov's character to reveal the child's own doubled perspective on his life: it is no accident that in several scenes, there seems to be more than one Ivan on the screen. By probing deep into this character's psyche and, in several sequences, presenting the world as he sees it, the film places the viewers in a similarly ambiguous position. As in all of his work, Tarkovsky brings a delicate focus to the edge at which the physical nature of the world before us meets the ethereal, nonphysical side of our lives – the world of thought, memory and dream. Ivan, like so many of Tarkovsky's protagonists, is the point at which we

see these aspects of reality collide and intersect. But the depiction is more than simply the vague artistic realization of abstract philosophical or mystical ideas; in fact, the parallels to philosophy and theology, although largely coincidental, may often be quite specific. At the heart of Tarkovsky's work, there lies an intense examination of human relationships, but one much different and much more profound than is usually encountered in dramatic works. With the opening of Ivan's mind, the film creates unobtrusive, yet unmistakable associations with the adults around him. The fraught nature of their relationships, complicated by the ambiguous motivations of the Soviet officers, heightens our emotional involvement with these figures. As the second half of this book will illustrate, these relationships open the door to a deeper investigation into the nature of consciousness, perception, and the possibilities of transcendence. This is particularly important in the consideration of the young Lieutenant Gal'tsev, who both literally and figuratively comes to serve as a kind of mirror image of the boy and, more than any other figure in the film, suggests that some kind of equilibrium may still be found in the midst of the war's chaos.

Before launching into a comprehensive analysis of *Ivan's Childhood* in the second half of this book, it is worth taking another look at the history of its production. How the project, nearly written off by Mosfilm, ended up in the young director's hand is a fascinating story on its own, and I will expand upon some

of what has been written on this subject in more general studies of Tarkovsky's work. But, as no auteur works in isolation, it is necessary to draw more attention to the collaborators on the film, many of whom would soon become major figures in Soviet cinema and were instrumental to the success of this work. In this respect, the evolution of the story itself is also of special interest. The film's relationship to Vladimir Bogomolov's 'Ivan', an intriguing work in its own right, remains an aspect that has yet to be fully examined. Though Tarkovsky was an accomplished original screenwriter, he was certainly not averse to adapting literary works. In addition to the completed versions of Stanislaw Lem's *Solaris* (1972) and Arkadii and Boris Strugatskii's *Piknik na obochine* (*Roadside Picnic*, 1971; rechristened *Stalker* for the 1979 film), he had contemplated adapting works by Fedor Dostoevskii, Aleksandr Solzhenitsyn, and others. 'Ivan', as an earlier failure demonstrated, was not an easy work to arrange for the screen. Surprisingly, and in some rather understated ways, this film version often remains quite close to Bogomolov's original framework. Fidelity to the source, however, is not the primary concern; it is the deviations – some major, which make this film such a powerful work of art. And this is largely how *Ivan's Childhood* was received upon its premiere.

From an introduction of the central characters and detailed summary, the analytical section of this book will gradually move into an examination of the film's

hidden depths. Although it seldom receives the attention it deserves in this respect, *Ivan's Childhood* exhibits a deceptively complex narrative structure and profound philosophical underpinning. While I treat the film as an important and fully realized work of art, this does not mean that there are not some growing pains along the way. Though not an uneven piece artistically, it possesses neither the technical dexterity nor the sheer audacity of its immediate successor, *Andrei Rublev*. Tarkovsky himself later referred to the film as his 'qualifying examination' (Tarkovsky 1986: 27), an unfortunate turn of phrase that has perhaps done more than anything else to persuade some viewers that, due to the occasionally rough edges or simply the fact that it was made early in his career, this is a second-rate Tarkovsky film. To be sure, there is much here that is experimental for the new film-maker. But Tarkovsky also engages in techniques he would never use again so conspicuously, like the whip pan, and makes uncharacteristic (and perhaps excessive) use of canted angles. The expressionistic flashes of a negative background, though effective in the film's third dream sequence, seem almost naïve in light of the powerful oneiric images of the later works. More striking is what seems to be missing. The long takes that were to become a hallmark of Tarkovsky's later style are nearly absent here. Unlike every other Tarkovsky film, there is no colour, no use of slow-motion photography and, with certain exceptions, little that would greatly alarm the censors of the early 1960s.

10

And yet, as an introduction to the work of one of cinema's most profound thinkers and gifted artists, the film still hits the right notes. The film scholar Maya Turovskaya, in one of the first thorough evaluations of Tarkovsky's work, noted retrospectively that some aspects of this film may seem 'ingenuous and dated', but this can only be true relative to the director's own later works (1989: 1). Offering direct, point-by-point comparisons between *Ivan's Childhood* and, say, a film like *Solaris* tend to deviate from the unique qualities of both. And in the end, whatever technical differences there may be, do little to obscure what emerge as the prime aesthetic and ontological issues throughout Tarkovsky's artistic career. Even without the signature long takes, we feel the pressure of time, we sense the disintegration of normal spatiotemporal relationships and, correlative to this, a marked tension between the physical world before us and the virtual world of memory and dreams. In addition to the unspeakably tragic story of a child soldier, perverted by loss, hatred and trauma, *Ivan's Childhood* isolates and examines the points at which these realities intersect and overlap. These concerns, which dominate all of the film-maker's later works, are expressed here with a stylistic nuance no less absorbing than anything that would come after. In fact, these nuances were detected immediately by some particularly keen minds in the initial months of the film's release. Therefore, equally important to my discussion in the analytical section of the book, and not just for

historical perspective, is the film's critical reception at home and abroad. Jean-Paul Sartre's trenchant defence of *Ivan's Childhood* shortly after its premiere in the West set the stage for all subsequent analyses, but it is, in retrospect, clearly the result of a single and somewhat flawed viewing. While many of the points the philosopher makes are critically important for getting beneath the surface of the work and have exerted a decisive influence on later critiques, the resonance the film had with the contemporary Soviet audience is no less significant. Sartre is undoubtedly the most important early commentator on the film, but film scholars Maya Turovskaya and Neia Zorkaia offered early perspectives on the film which are often no less compelling.

1
Production History and Context

In terms of plot, *Ivan's Childhood* is arguably the most compelling of Tarkovsky's seven features. Not only do things actually *happen*, several scenes are genuinely exciting, and questions over the fate of the central character are a source of dramatic tension throughout. But the genesis of the film itself is no less interesting. As Tarkovsky's biographer Viktor Filimonov put it, 'the story of this film's creation has long since become a legend' (2011: 111). Few studies of Tarkovsky's work have neglected the chronicle of its inception, and the series of fortuitous incidents which placed this work in the hands of the young film-maker almost seem as if they were directed by the hand of fate. The story that would become *Ivan's Childhood* was taken from a remarkable novella by the hitherto unknown Soviet author, Vladimir Bogomolov (1926–2003). In some very important respects, the basic plot of 'Ivan' differs little from the one Tarkovsky would eventually follow, though there is nothing comparable to the bold artistic flourishes and psychological depth added by the film-maker. Despite some twists and turns

along the way, the revised script, which was written by Tarkovsky and Andrei Konchalovsky, brings the story far closer to the original version than an earlier, and wisely aborted iteration.

Bogomolov's story, which was his literary debut, first appeared in the journal *Znamia* in 1958 and remains his most popular and anthologized story. The relationship of this work to the finished film will be discussed in more detail below, but even with the glaring deviations from the original created by the addition of the dreams and an often tight narrative connection to the title character, the film just as frequently adheres to its source through the perspective of the story's first-person narrator, Lieutenant Gal'tsev. The first attempt to adapt the work, however, seems almost impossibly distant from both the original story and the eventual film. Originally entrusted to the newly minted actor and director Eduard Abalov, himself a recent graduate, progress on the adaptation proved unacceptable to the authorities at Mosfilm, and the production closed in October 1960. By the summer of the following year, Tarkovsky, Vadim Iusov (the cinematographer of his student film, *Katok i skripka* [*The Steamroller and the Violin*]) and the production designer Evgenii Cherniaev were given permission to resume work on the film, the expenses of which, even before this point, had been written off. Despite the added pressure of taking up a failed project, the team, which included the co-script writer Andrei Konchalovsky, managed to

complete shooting in January 1962 and, by the end of that month, they were able to present a rough cut. Though there were, naturally, a number of procedural and ideological issues blocking a direct path through the channels of Soviet bureaucracy, the film emerged relatively unscathed and, as Turovskaya notes, earned Tarkovsky some surprising praise for his technical and economic efficiency. As she quotes, the director 'always knew what to shoot, and had a thorough, all-round grasp of the technical aspects' (Turovskaya 1989: 33). It was praise that would become increasingly rare as the years passed. *Ivan's Childhood* set a number of precedents that would continue throughout the director's career, but plaudits from the Soviet film industry, expedited shooting schedules and fiscal discipline were not among them.

Perhaps the single most important aspect of the film's creation is the brilliant reconceptualization of the previous scripts and adaptation of Bogomolov's original story. As Vida Johnson and Graham Petrie note, although credit for the script is given to Bogomolov and the screenwriter Mikhail Papava, the final version is so different from earlier iterations of the story that much of the real credit must go to Tarkovsky and Konchalovsky (1994: 67). And indeed, the vicissitudes of the script were surprisingly substantial for what is, in comparison with some of the later films, a relatively simple plot. Papava's early reworking Bogomolov's story met with strong objections from the original author and seems a far cry from both the novella

15

and the final film version. According to Turovskaya's chronicle of the film, Papava divided the narrative attention between Ivan in the first half and Gal'tsev in the second (1989: 31). While the finished version bears some marks of this split, Papava somehow gave the film a happy ending, with Ivan surviving the war and unexpectedly meeting Gal'tsev later in life - a conclusion which in no way comported with the reality of young scouts serving on the front lines. Even though the stark, abrupt ending of the Konchalovsky/Tarkovsky version is closer to the original than this sadly far-fetched, Hollywood-style ending, Bogomolov found no shortage of things to fault in the newer rendition. For the most part, this seems to be due to an inattention to military detail - having Konchalovsky himself appear as a frontline soldier in glasses certainly did not help - but Bogomolov did, according to Turovskaya, initially agree to the insertion of the dream sequences. As she notes, 'it may be that Bogomolov did not at once appreciate the complete change of structure that the inclusion of the seemingly innocuous dream sequences would bring about' (1989: 32), but it was the lack of realistic detail and Tarkovsky's refusal to mythologize the heroism of the scouts that were the main causes of his dissatisfaction.

From the time shooting was completed in January 1962 to its final approval in March, the film was the subject of some serious debate within the Soviet film bureaucracy, but nothing on the scale of what was to

16

befall Tarkovsky's following works (see Johnson and Petrie 1994: 67–69). The gruesome documentary footage preceding the film's final dream sequences and the somewhat incongruous romantic scene between Kholin and Masha in a birch forest were among the chief points to which the authorities and Bogomolov himself objected. The film-maker stood his ground and, fortunately, the authorities largely failed to insist (Johnson and Petrie 1994: 68).

The success of *Ivan's Childhood*, particularly in the wake of the Venice Film Festival, garnered the young film-maker international renown and artistic gratification almost overnight. As Johnson and Petrie write, 'after *Ivan's Childhood* no serious discussion of Soviet film could leave out the figure of Andrei Tarkovsky' (1994: 69). This, of course, remains the case today, but the road to this point began several years before the film's unexpected success at home and abroad. Tarkovsky's student work, though not as accomplished or professional, produced some extremely interesting and, in some places, extraordinary scenes whose relevance has only increased with the director's growing international fame.

This is especially the case with his diploma project, *The Steamroller and the Violin*, a work which has often flown beneath the radar of scholars, but was very much within the artistic current of contemporary European cinema. Undeniably the work of a 'student' film-maker, there are already traces of a daring artist and thinker whose talents, along with those

of an exceptionally gifted crew working behind the scenes, were on the verge of moving beyond anything hitherto seen in Russia.

Tarkovsky's student work

Tarkovsky's unintentionally facetious description of *Ivan's Childhood* as a kind of test case before truly setting out on a career as a film-maker perhaps made some sense in light of the scale of subsequent projects, but it is literally the case with *The Steamroller and the Violin*. This short work, a comparatively elaborate student project which benefited from many of the talents that would later craft both *Ivan's Childhood* and *Andrei Rublev*, was one of the first real instances of the new film-maker being more or less on his own. Though it was made under the supervision of the experienced (and exceptionally talented) Soviet director Mikhail Romm, who was obviously an important mentor to the directorial students at VGIK, the short film is unmistakably the work of the budding Andrei Tarkovsky. Moreover, despite the fact that it is clearly a student work, *The Steamroller and the Violin* was not his first directorial experience. As a student, he co-directed with Aleksandr Gordon and Marika Beiku the short film *Ubiitsy* (*The Killers,* 1956), an adaptation of Hemingway's 'The Killers'. Other than the fleeting presence of Tarkovsky as a restaurant patron, Gordon as the bartender and, appearing briefly in the role of Ole Anderson, the writer and director Vasilii Shukshin, there is little

remarkable and much that betrays the fifteen-minute film as essentially a laboratory for new cinematic techniques. The incessant play with mirrors and windows as framing devices, a few canted angles and a skilfully executed whip pan are techniques that would be used again, to much better effect, in *Ivan's Childhood* and quite interesting in retrospect, but mostly overdone for a piece of this scale.

Segodnia uvol'neniia ne budet (*There Will Be No Leave Today,* 1958), which was released on Soviet television in 1959, was a far larger and more thoroughly professional project. However, there are even fewer marks that would distinguish it as film by Tarkovsky. Once again, the novice director uses the whip pan and the film contains a number of interesting tracking shots, but for the most part, the 45-minute production is a thoroughly conventional piece. The heroism of everyday citizens is lauded and the acting is very much up to par, but the music is occasionally overbearing and the film's plot, centred around the discovery and painstaking removal of 30 tons of German explosives left over from the war, is probably not one that suited the talents behind the camera. There is a strained attempt to convey tension in the removal and handling of the unexploded bombs, but it is often preposterously unconvincing. Obviously, making a thriller was not the film-maker's forte, and, for many of today's viewers, the most interesting part of the film is likely the young Tarkovsky himself lighting the fuse that finally destroys the weapons.

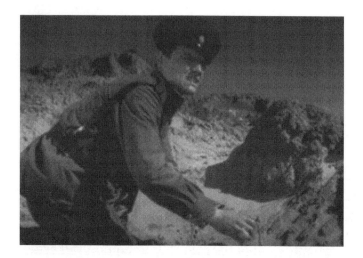

Figure 1.1: Still from Aleksandr Gordon and Andrei Tarkovsky's student film *There Will Be No Leave Today*.

The Steamroller and the Violin, on the other hand, is a remarkably original work with several unmistakable indications of Tarkovsky's future directions. Simply the fact that it takes a child as its main character betrays its kinship with *Ivan's Childhood*, but a number of other thematic and structural factors suggest an even tighter bond between the two films. As with the works that follow, the screenplay was co-written with Andrei Konchalovsky, while Viacheslav Ovchinnikov composed the original score. In an odd stroke of luck, Tarkovsky's original choice for the cinematographer, Sergei Urusevskii, turned down the job – he had already achieved major recognition for his impeccable work on Kalatozov's

Cranes Are Flying – and it went to the much younger Vadim Iusov.[2]

The Steamroller and the Violin is, by any standard, a charming film with a number of genuinely moving moments; in scale and execution, it far surpasses what could normally be expected from a student film-maker. Produced in 1960, it was already a strong departure from standard Soviet fare and much closer to the contemporary works of European film-makers like Michelangelo Antonioni and Alain Resnais than its tame subject matter would indicate. Like *Ivan's Childhood*, it offers some bold challenges to traditional modes of cinematic perspective and innovative manipulations of temporality.[3] We can see a parallel to the relationships of Ivan and the soldiers serving with him in the growing friendship between the schoolboy Sasha and the construction worker Sergei, and in the various levels of reality and time that coexist and intertwine while fleeting moments of transcendence emerge within the details of everyday life. Though it is perhaps true that, if Tarkovsky had not gone on to make other films, this short would have been lost among the dozens of others produced at the studio, *The Steamroller and the Violin* is undoubtedly a piece deserving of attention. As a testing ground for techniques and tropes which would mark the future films, it is especially significant.

This is not to say that the film is unable to stand on its own merits, which, in some cases, are considerable, but rather because the director is quite

21

obviously experimenting with techniques and motifs he would either modify or totally abandon in the coming films. It is clearly the work of talented artists, but *The Steamroller and the Violin* does not yet possess the gripping integration of form and theme nor the visual and intellectual density of the larger productions. In terms of plot, it seems almost a shallow relative to the gaping psychic wounds, emotional trauma and flashes of transcendence that distinguish works like *Stalker* and *Solaris*. Yet the seeds of these future directions are not hard to find, and much of what fascinates in this diploma work, especially the brightly drawn fantasies of the young violinist Sasha, has direct links to fuller realizations in *Ivan's Childhood* and, perhaps even more so, *Andrei Rublev*. To be sure, any viewer must bear in mind that this short film is hardly intended to be a complete work of art on the scale of these later works but rather, as Vida Johnson and Graham Petrie describe it, a deliberate exhibition 'to show off the young director's creative potential and technical virtuosity' (1994: 63). In this, the film was a resounding success.

More than 60 years on, it may be difficult for Western viewers to recognize what was so palpably Soviet in the film. The budding friendship, upon which the story is built, mirrors countless others in Soviet cinema and literature, where a member of the intelligentsia (the 7-year-old Sasha) bonds with a peasant or worker (here the steamroller driver Sergei). Not coincidentally it is *Chapaev* (dir. Vasil'ev Brothers, 1934),

an undisputed Soviet classic in this regard, which Sasha and Sergei plan to see together at the conclusion of the film. But even with constant emphasis on the reconstruction of Moscow and the implicit references to building a brighter future, *The Steamroller and the Violin* displays none of the propaganda or jingoism found in the films of the Stalin era. But it still remains a far cry thematically from the new horizons being explored at the time by film-makers like Chukhrai, Kalatozov and even Mikhail Romm, artists whose company Tarkovsky would soon join, if not surpass, with the release of *Ivan's Childhood*.

Significant aspects of the next film are already visible here, albeit at an early, underdeveloped stage. Sasha's father, like Ivan's, is conspicuously absent (in fact, he is never mentioned), and his figurative adoption by a surrogate in the form of the kind Sergei is frustrated. More importantly, mirrors, perhaps the most significant image in both films, form a dominant and recurring motif. From a more technical standpoint, there are significant similarities in the way the director handles a multiplicity of perspectives and the use of subjective angles when initiating or dispersing daydreams and reveries. Characteristically, these moves are linked with mirrors or water, images whose significance gradually deepen as they are repeated. Despite being in the very early stages of his career, Tarkovsky is already able to interconnect these and various other images to a discernible pattern that binds the aesthetic framework of the film together.

As in his later work, the significance of prominent images like mirrors and clocks are expanded and developed through repetition and slight variation, such as reflective pools of still water, windows and even a metronome.

The mirror often marks a kind of liminality separating the physical world of the here-and-now with the virtual world of dream and memory. *The Steamroller and the Violin* does not yet approach the intellectual depth of the other works, but it is clear the film-maker has already marked his path and developed a clear idea of how to slice through everyday perception and evoke deeper layers of reality. This is on full display in a masterful sequence in front of a shop-window early in the film, where Sasha pauses to watch reflections of the surrounding city. As the film progresses, numerous brief repetitions, or reminders, of these cracks in the surface of the world we see in this scene reappear with telling frequency. They may be as subtle as the flashes of sunlight reflected on Sasha's face from windows or streams, or as explicit as an inverted reflection of the characters in a pool of water. As in all of Tarkovsky's films, and despite the novelty of his use of an urban setting (*Mirror* is the only other film to feature contemporary Moscow), water saturates the landscape. Even during the brief acquaintance of Sasha and Sergei, the film-makers manage to insert a raging thunderstorm, making the lingering spots of water and any other reflective surfaces recurring focal points of the narrative.

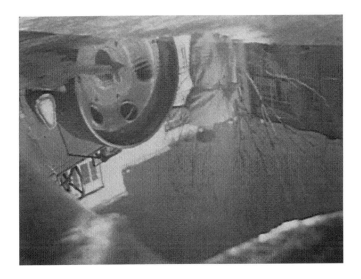

Figure 1.2: Reflection of the steamroller.
Still from *The Steamroller and the Violin*.

The clock initially functions as a marker for Sasha's obligations (such as they are) and cares in the world around him; something of a nemesis which calls him back from his daydream in front of the shop-window and, as the metronome, regulates his creative impulse. The combination with the mirror, however, creates a much different effect. In the scene before the window, the mirror image of the street clock moves in reverse, openly calling attention to the spatiotemporal distortions within this quasi-fantasy. Characters glimpsed just before he approaches the window reappear in impossible positions, as does the boy himself as he turns to glance at the reversed and multiplied

25

reflections of the clock (Figure 1.3). But this also marks the beginning of the end of the sequence, as the image itself seems to call Sasha from his reverie. Not coincidentally, a similar combination occurs just before the final daydream of the film. Sitting at his mother's vanity mirror, Sasha turns a small clock to face the mirror (actually to a glass of water in front of the mirror), physically reversing time, just before the screen begins to blur and the camera follows an invisible figure down the steps of the apartment building and then the boy himself out into the streets (Figure 1.4). The final shot of Sasha chasing the steamroller is actually a close variation of an earlier overhead shot where Sasha and Sergei reunite after the thunderstorm. As in that earlier shot, Sasha crosses a literal and figurative boundary that will reappear in various guises in *Ivan's Childhood*, running through a thin stream of water that separates him from his friend.

These fantastic sequences, brief though they are, mark an important similarity between the two films. In Sasha's case, these are best seen as wish fulfilments, particularly in the final shots of the film, rather than the shards of a broken childhood. More importantly from a technical standpoint, sequences like those before the window, the imagined reunion with Sergei and a daydream at his music lesson all take us into Sasha's subjective realm without resorting to more traditional point/glance shots. Tarkovsky is justly famous (or infamous) for blurring the line between fantasy and reality, and the practice is already firmly

Figure 1.3: The fracture of time.
Still from *The Steamroller and the Violin*.

Figure 1.4: Sasha at the mirror.
Still from *The Steamroller and the Violin*.

established in this student film. In the sequence at the music lesson, for instance, the camera slowly tracks from an objective angle of the boy playing to a subjective position on the sheet music and then a blurred carafe, which then moves back into focus along with the attention of the child – a clear predecessor to the numerous forays into the mind of Ivan. What is most interesting here, and very much like Tarkovsky's later work, is that this shift in perspective and a distortion of spatiotemporal relationships all takes place within the space of a single shot. Like those of *The Steamroller and the Violin*, the dream sequences of *Ivan's Childhood* also frequently play with narrative subjectivity and are filtered through the perspective of the protagonist. It is often unclear, as in Ivan's waking dream, whether we are looking through the eyes of the child or taking an objective stance within the fantasy. This critical scene, in which the camera is looking through the eyes of Ivan even as he steps into the frame, marks an interesting reversal of Sasha's music lesson, where we see a close-up of the boy playing but then slowly slide into his perspective, which itself seems to be what distorts the visual and the spatial arrangement of the room.

For all its merits, one of the more negative aspects of *The Steamroller and the Violin* is the depiction of women, which is always a problematic area in Tarkovsky's work. Most of the films are completely dominated by men (*Mirror*, again, may be considered an exception) with women usually consigned to

Figure 1.5: Sasha at the lesson.
Still from *The Steamroller and the Violin*.

secondary positions, if not caricatures. The apparent chauvinism is no accident; Tarkovsky has been justly taken to task in interviews and criticism for his anti-quated views and often dubious female characters. Like so much of his work, including *Ivan's Childhood*, the focus of *The Steamroller and the Violin* is primarily on the men. This is especially true when it comes to the depiction of artists. Nowhere in Tarkovsky's oeuvre is there a female equivalent to a character like Andrei Rublev, Alexander (in *Offret* [*Sacrifice*], 1986) or, for that matter, Sasha. With their 'sufficient spirit to *not* create' (Gianvito 2006: 134), women are most often set in dependent roles (the extreme

perhaps being Hari in *Solaris*, whose very existence is generated by the synthesis of Kelvin's memories with the thinking ocean of the planet) and at their most negative when striking out independently from the world of men or demanding masculine attention. In this last regard, Sergei's amorous co-worker seems a clear predecessor to Eugenia from *Nostalghia* and her pursuit of the married Gorchakov. The thin depiction of Sasha's mother also seems part of these tendencies. It is her inability to understand her son, after all, which finally prevents his planned meeting with Sergei at the end of the film.

In many respects, it is increasingly clear that the more deeply we look into this student film, the more clearly it becomes a harbinger of the work to come. Though the innocence of the plot would seem to have little in common with the later films, the innovative presentation of time and manipulation of perspective form a direct line to what would come later. Even the use of a child protagonist, something repeated only with Ivan in the subsequent films, sets a marker for future directions. Josephine Woll, for instance, has noted that in Sasha, we have a preliminary version of what was to expand considerably with *Andrei Rublev*: 'the image of the artist as outsider in a cold and comfortless world' (2000: 138). The situation of the protagonist in *The Steamroller and the Violin* is, thankfully, far less dire. In fact, this figure who reaches out into the transcendent need not necessarily be an artist in the strictest sense – as in the case of the eponymous

Stalker – but Sasha's precocious talent clearly places him in a position most similar to that of Rublev or, much later, Alexander. And as with them, the viewer is guided through the boy's perspective as it relates the director's zen-like attention to detail, to the miracles found in the tiniest and most ordinary elements of the everyday world. As Iulii Smelkov, one of the earliest reviewers of *The Steamroller and the Violin*, so astutely stated as one of the main themes of the film: 'In the world there are a lot of wonders – one needs only to be able to see them in the most ordinary things and events' (1961: 25).

Collaborators

> *It is extremely important, and at the same time very hard, to make set designer and camera-man (and for that matter all the others working on the film) into partners, collaborators in your plan.*
>
> (Tarkovsky 1986: 135)

Despite its being a student film, Tarkovsky was not the only major talent working on *The Steamroller and the Violin*, and several members of this team would carry over into the next work. As with any motion picture, even those of *Ivan's Childhood*'s modest scope, there are dozens of people working in front of the camera as well as behind the scenes who rarely get their due. Before proceeding into an analysis of the film, some brief words are in order on a few of the other artists

31

who contributed to the film, but may not be as well known as the director. To put it mildly, Tarkovsky's relations with his collaborators were sometimes difficult. Konchalovsky, for instance, later recounted shouting matches over the use of documentary footage at the conclusion of the film, but there nevertheless seems to have been less tension behind the scenes than would later be the case (Konchalovskii 1989: 229). Not yet having reached the status of an internationally renowned auteur, the strain created by differing opinions or ideas must have been considerably lighter and, under the circumstances, most of the crew may have felt they had less to lose. As Tarkovsky later wrote, the production was an opportunity for experimentation. This was particularly so in dealing with the dream sequences: 'Casting about for an answer we tried out several practical possibilities, using associations and vague guesses' (Tarkovsky 1986: 30). And in spite of the tight schedule of a such a limited production, Nikolai Burliaev, who makes no secret of his reverence for Tarkovsky, later described the atmosphere on the set as relaxed, while time off from shooting was especially collegial and enjoyable (Burliaev 1989). Like co-screenwriter Konchalovsky and cinematographer Iusov, several artists working on *Ivan's Childhood* would collaborate again with the director in the future. Nikolai Grin'ko (1920–89), who plays Colonel Griaznov, would continue working with the director on every film up until Tarkovsky's emigration.

Much like Tarkovsky, Andrei (Mikhalkov-)Konchalovsky (b.1937) has himself become a Russian cultural institution. Of the numerous contributors to the film, he is the best known in the West as well as in Russia. Several years younger than Tarkovsky, Konchalovsky was also a student of Mikhail Romm and, prior to their collaboration on this film, worked on the screenplay for *The Steamroller and the Violin*. In addition to a brief appearance on screen as a young soldier clumsily accosting Masha, he introduced Tarkovsky to Nikolai Burliaev (b.1946), who had the lead role in Konchalovsky's short film *Mal'chik i golub'* (*The Boy and the Pigeon*, 1961) and would play the role of Ivan. The three of them collaborated again on *Andrei Rublev*, but, by the time of its completion, Konchalovsky had already established himself as a solid filmmaker with his own feature-length *Pervyi uchitel'* (*The First Teacher*, 1966).

Thanks in part to his long artistic career following the fall of the Soviet Union, Konchalovsky has been a much more prolific film-maker, though he too had his problems with the authorities. One of his most impressive works, *Istoriia Asi Kliachinoi (Asya's Happiness*, 1967), earned a twenty-year exile to the film vaults for its unexpectedly honest depiction of life in the Soviet countryside. The film was shot by Georgii Rerberg, who would go on to serve as Tarkovsky's cinematographer on both *Mirror* and *Stalker*. Despite the setback, Konchalovsky continued to work, notably on films such as the adaptation of Ivan Turgenev's

novel *Dvorianskoe gnezdo* (*A Nest of the Gentry*, 1969),
Anton Chekhov's *Diadia Vania* (*Uncle Vanya*, 1970)
and the massive *Siberiade* (1979). In the 1980s,
Konchalovsky worked in the United States and made
several Hollywood films, including *Runaway Train*
(1985) and (before walking off the set) the Sylvester
Stallone vehicle *Tango and Cash* (1989). Working
again in Russia after the collapse of the Soviet Union,
he enjoys wide renown as one of the great elder
statesmen of Russian cinema. Though he continued
to occasionally work in the West after returning to his
homeland in the 1990s, his work in Russia reached
another high point with *Dom durakov* (*House of Fools*,
2002), a relentlessly original and often surprising
take on the war in Chechnya. In later years, the qual-
ity of his work has continued unabated; both *Belye
nochi pochtal'ona Alekseia Triapitsyna* (*The Postman's
White Nights*, 2014) and *Rai* (*Paradise*, 2016) took
home the Silver Lion from the Venice Film Festival.
He also released a joint Italian-Russian project on the
life of Michelangelo, *Il peccato* (*Sin*, 2019), and com-
pleted *Dorogie tovarishchi* (*Dear Comrades*) in 2020,
which won him a Special Jury Prize in Venice.

Along with Konchalovsky, Vadim Iusov (1929–
2013) is arguably Tarkovsky's most important collab-
orator on *Ivan's Childhood* and, indeed, all of the direc-
tor's early films. A look at the four films they made
shows two emerging talents who, at least in terms of
the finished product, appeared to develop marvel-
lously together. The cinematographer's work with

colour in *The Steamroller and the Violin* nearly comes to define the work as a whole, and the stunning artistic success of *Andrei Rublev* is due in no small part to his at once restless and meditative camera. Following *Solaris*, their fourth film together, the collaboration came to an end as Iusov reportedly objected to the highly personal nature of *Mirror* (then under the working title *White, White, Day*; see Johnson and Petrie 1994: 43). Despite the fine work of Georgii Rerberg on the film, numerous differences are clear. Something obviously changes in the visual style of the two films made in the Soviet Union following the split between Tarkovsky and Iusov, and it is interesting to speculate on how the latter would have handled the slow tracking and deep focus shots of a film like *Stalker*, particularly in light of the tight kinesthesia that characterizes *Andrei Rublev* and *Solaris*.[4]

Iusov's visuals in *Ivan's Childhood* (and the later films) are fully realized by the original score of perhaps the most important composer working in Soviet cinema during the 1960s and 1970s. At times understated or expressionistic, Viacheslav Ovchinnikov (1936–2019) began composing at age 9 and by his early 20s was already writing music for Soviet film and television. He worked repeatedly with both Tarkovsky and Konchalovsky in the 1960s. In addition to *Ivan's Childhood*, he wrote the score for *The Steamroller and the Violin* and *Andrei Rublev* for Tarkovsky, and *The First Teacher* and *A Nest of the Gentry* for Konchalovsky. He famously worked with Sergei

Bondarchuk, composing the music for the epic *Voina i mir* (*War and Peace*) in the mid 1960s, as well as *Oni srazhalis' za rodinu* (*They Fought for the Motherland*, 1975). Though his last film scores were in the 1980s, Ovchinnikov continued to add to his oeuvre symphonies and a number of suites, concertos and symphonic poems before his death in 2019.

Casting

Tarkovsky is often credited for discovering the remarkably talented child who would become the star of the film, yet Nikolai Burliaev had already appeared in Konchalovsky's short *The Boy and the Dove* in 1960 and Igor' Talankin's *Vstuplenie* (*Entry*, 1962). In fact, it was Konchalovsky who first gave Burliaev the script for *Ivan's Childhood*, which truly marked the beginning of a remarkable career as both an actor and a film-maker. Burliaev's collaboration with Tarkovsky would extend to *Andrei Rublev*, where the young actor took on the crucial role of the adolescent bell founder Boriska in the film's final episode.[5]

The role of Lieutenant Gal'tsev was one of the first for 21-year-old Evgenii Zharikov (1941–2012). At the time of *Ivan's Childhood*, Zharikov was still a student at VGIK, but had had an earlier part in another critical Thaw-era film, *A esli eto liubov'?* (*But What if This is Love?*, 1961), directed by Iulii Raizman. Zharikov compiled a long list of roles, appearing in well over 50 films, and although he received numerous awards and served as president of the Russian and Soviet

film actors' guilds, it is his role in Tarkovsky's debut for which he is most remembered.

The same can be said for many of the remaining artists appearing in the film. Irma Rausch (b.1938), Tarkovsky's first wife, only appeared in a few films outside of the two directed by her husband; she played Ivan's mother. Her limited dialogue (she only speaks in one of the dream sequences) is reduced even further in *Andrei Rublev*, where she takes on the more extensive role of the mute *durochka* ('fool') in the film's central episodes. Valentina Maliavina (b.1941), who was romantically involved with Tarkovsky while *Ivan's Childhood* was being made and shortly thereafter (she too was married; see Filimonov 2011: 117), is also best known for her role in this film, but her own life story, which includes a lengthy stint in a Soviet prison, is as fascinating as any fiction.[6]

By the time he was cast as Kholin, Valentin Zubkov (1923–79) had already played a part in perhaps the most important Soviet film of the 1950s, Kalatozov's *Cranes Are Flying* as Stepan, the best friend of Aleksei Batalov's character Boris. He was one of the few working on this film who had actually fought in the war.[7]

Nikolai Grin'ko, here in the smaller role of Colonel Griaznov, is arguably the most recognizable figure in all of Tarkovsky's Soviet films: he occupies a significant place in each of them. He took on major roles for *Andrei Rublev*, in which he played Daniil Chernyi, the mentor and friend to the title character; and in *Stalker*, where he played the bomb-toting Professor,

apparently the least neurotic of the trio heading into the zone. In *Solaris*, he was the father of the protagonist Kris Kelvin; and, in *Mirror*, he had a lesser role as the director of the printing workshop.[8]

From story to film: Vladimir Bogomolov's 'Ivan'

The nearly complete take-over of the screenplay by Tarkovsky and Konchalovsky notwithstanding, the basic story of *Ivan's Childhood* very much remains that of its original author. Born in 1926 in the village of Kirillovka outside Moscow, Vladimir Bogomolov (known as Voitinskii until 1957) was a fairly new figure on the Russian literary scene. 'Ivan' was his first publication and, despite his lack of literary training, an immediate success. Yet Bogomolov never really became part of the Soviet literary establishment and, though the quality of his work was impressive, published only infrequently. Within a year of 'Ivan', Bogomolov published the series of stories 'First Love', but it was not until several years later (1964 and 1965) that his next works – including 'Zosia', which was adapted for the screen in 1967 by Mikhail Bogin – finally appeared. He achieved some success again in the 1970s with the novel *V avguste 44ogo* (*In August 1944*) (also called *Moment of Truth*) but, despite several invitations and offers of improved medical care, automobiles and trips abroad, Bogomolov obstinately refused to join the Union of Soviet Writers – a point recounted with considerable pride in his reminiscences (Bogomolov 2007: 731–32).

Like 'Ivan' and the earlier stories, Bogomolov's novel is set during the Second World War. While not based precisely on the author's personal exploits, his works all rely on his wartime experiences. Though still a boy, Bogomolov joined the fight against the invading Germans in 1941 and, like his character Ivan and so many of his countrymen, was familiar with the horrors the war brought to the Soviet Union.[9] Considering the somewhat dry, meticulous attention to detail in his literary work, it is rather surprising that in later years, some journalists and researchers have cast doubt on Bogomolov's military career, citing a lack of documentary evidence for many of his claims. This aside, there is no question he is indeed the author of the works credited to him and their composition undoubtedly demanded a high degree of intimacy with military details and procedures. Given the thorough technical descriptions that pervade 'Ivan', it is no surprise that Bogomolov would find fault with Tarkovsky's comparative lack of concern for such particulars.

The novella 'Ivan', like the screen version five years later, was an unexpected triumph from a hitherto unknown artist. While the differences between the story on the page and the final version of the film are substantial, many points from the overall plot are more or less the same (Bogomolov 1987; Tarkovsky 2003: 55–126). Bogomolov's story begins with Lieutenant Gal'tsev being awakened by the lance corporal Vasil'ev (a character expanded in the film) and

finding that his men have detained an emaciated 11-year-old who refuses to answer any questions. At 21 and already a battalion commander, Gal'tsev's experiences in the war have conditioned him to be surprised at nothing, but the domineering child immediately stimulates his curiosity and he soon develops a tender attachment for the boy. As in the film, these two main characters spend relatively little time together; Ivan moves in the circles of military intelligence and is, thus, closed off to Gal'tsev, who spends most of the story dealing with the abrasive Kholin and the easy-going Katasonov (Katasonych in the film). Naturally for a story with a first-person narrator, scenes of Ivan alone or with characters other than Gal'tsev are either entirely absent or simply reported to the lieutenant by others. Such is the case with Ivan's argument with Griaznov over being sent to military school. Ivan does run away in Bogomolov's original story but, in a significant disparity with the film, this happens considerably later, after the second (and in Tarkovsky's version, final) mission across the river. The film, which keeps a much tighter hold on some information, leaves us to assume that Ivan is captured some time during the course of this second mission. In Bogomolov's story, he survives this mission only to be captured later by a Russian collaborator and shot on 25 December 1943. In both cases, the reader or viewer only learns of his death when Gal'tsev finds the file on the boy amidst the ruins of the Gestapo headquarters in Berlin.

40

Though the basic similarities with the story are quite clear, the film adaptation signals immediately, in its departure from the perspective of Gal'tsev, that it has a very different focus than 'Ivan'. While there is certainly much that he found appealing in Bogomolov's story, Tarkovsky claimed later to have 'derived little joy from the detached, detailed, leisurely narrative with its lyrical digressions to bring out the character of the hero, Lieutenant Galtsev' (Tarkovsky 1986: 16). But it is in the empty factual details he finds space for the alterations he termed 'poetic articulations' (Tarkovsky 1986: 30). The most obvious of these are, of course, the emotionally charged dream sequences, which effectively create an alternate narrative plane, distinct from the film's realistic diegesis. Tarkovsky also introduces the beginnings of a romance between the characters of Kholin and Masha and, in one of the most memorable sequences of the film, adds the frightening waking dream, a scene which seems to float halfway between traumatic hallucination and ghostly visitation. A similar addition is the surreal encounter in the ruined *izba* between Ivan and seemingly delusional old man. Like everything outside of Gal'tsev's immediate knowledge, this had no place in Bogomolov's story. The action that sets up this meeting, Ivan's flight to join the partisans rather than being sent away from the front, does occur in the book, but the information is related to Bogomolov's narrator by Colonel Griaznov long after it has taken place. A more significant point,

41

and one that would trouble some of the film's first commentators, Gal'tsev's HQ is simply a *zemlianka*, or dugout, in the book.[10] The abandoned church that serves as the central location in the film, complete with bell, crucifix and frescoes, appears only in the film; this change is among the most significant from page to film. Tarkovsky's deep-rooted spirituality makes effective and, for many Soviet viewers, occasionally jarring use of the abundant symbolism. But there is more at work than simply the use of Christian imagery. As in Nikolai Gogol''s horror story 'Vii' (1835), empty churches are often thought to be haunted, filled with evil or restive spirits. It is a perspective which achieves particular salience when Ivan begins hearing voices and seeing spectral figures during his phantasmal game of war. Looking more deeply, abandoned churches, as Jurij Lotman and Boris Uspenskij discuss in their famous paper on the dynamics of Russian culture, are traditionally considered sites in which the opposition between good and evil or holy and unholy reaches a certain apex. The setting, thus, forms a fitting metaphor for the tragedy of Ivan, a character split by the innocence of his dreams and the horror of the war. While the Christian symbolism draws a distinct correlation between the mother and the child of the dreams and images of the Virgin and Christ, which occasionally appear in frescoes, the ruined church itself reflects the perversion of Ivan's innocence, as 'what had been holy could be changed into something evil' (Lotman and Uspenskij

42

1984: 8). And it seems to be precisely such a dichotomy that Tarkovsky had in mind when devising the modifications to the character. As he wrote later in *Sculpting in Time*, the innocent purity of childhood is torn away from the boy and 'the thing he had acquired, like an evil gift from the war, in place of what had been his own, was concentrated and heightened within him' (Tarkovsky 1986: 17).

This adjustment to the setting is only part of how Tarkovsky makes the story of the scout fighting the Nazi invasion his own and uses the foundation of Bogomolov's text to create an entirely new artistic fabric. As he later explained, the content of the story was simply a 'possible basis, the vital essence of which would have to be interpreted in the light of my own vision of the finished film' (Tarkovsky 1986: 18). While many of the larger elements of the story necessarily remain in place and the film does not stray as far from its source as it may initially seem, the transfer of perspective from the first-person narration of Gal'tsev in the book to Ivan in the film enables a fundamental structural and thematic shift. A number of commentators on the film take this move to be total; Maya Turovskaya in her initial review even equates Ivan with the narrator: 'Tarkovsky filmed a diametrically opposite point of view, showing us not Ivan at war, as seen through the eyes of the lieutenant, but the lieutenant, the war and everything else through the eyes of Ivan' (1989: 2). The reality is slightly more complicated. No matter how far the film strays

into the perspective of Ivan or other characters, it nevertheless retains significant traces of Gal'tsev's original narration. The analytical section of this book will take a closer look at how the film manipulates narrative perspective and how it attaches itself to, or sometimes immerses itself within, the consciousness of certain characters. But here it is important to note that, rather than relying simply on the perspective of Gal'tsev or Ivan, the film presents different perspectives on the world, and, at several key moments, explicitly fuses them together.

The main deviations from Bogomolov's story, namely the insertion of four dream sequences which essentially divide the film into two distinct yet occasionally interpenetrating narrative planes, would seem at first to completely exclude the perspective of the original narrator or anyone else but Ivan. Naturally, Bogomolov's 'Ivan' has nothing comparable to these scenes. Events are relayed exclusively via the mediation of the young Lieutenant Gal'tsev, and although the Ivan from the story displays many of the same characteristics as the boy in Tarkovsky's film, nothing is revealed about his inner life other than what the lieutenant is told or able to reasonably assume. Theoretically, in cinema, there cannot be an overarching mega-narrator functioning concurrently as a character within the diegesis. Thus, a clean transition, narratively speaking, from a literary first-person to a cinematic first-person narrator is essentially impossible. Instead, an adaptation creates

a tight spatial attachment to the first-person narrator of the hypotext, combined with a healthy dose of retrospective voice-overs. What Tarkovsky does with Bogomolov's story in this regard is quite innovative and essential to a comprehensive understanding of the deeper issues the film raises. Rather than remain with Gal'tsev, the first 30 minutes of *Ivan's Childhood* closely follow the title character, often with Gal'tsev significantly removed from the events on the screen. In the second half of the film, however, the narrative begins an inconspicuous shift in favour of Gal'tsev's perspective. This return to a semblance of structural fidelity is tempered by some interesting differences in the plot. As noted earlier, Bogomolov's story has Ivan actually returning from the final mission across the river and then running away to join the partisans. In the book, we come to know this through a conversation Gal'tsev has with Griaznov near the end. It is a subtle change that also points to some rather large implications for the film version. As we learn in the book, Griaznov has allowed Ivan to go on this second mission. So much of the moral ambiguity surrounding the character of Kholin, who in the film is conducting the scouting mission and risking the life of Ivan without the knowledge of Griaznov or anyone else, simply does not exist. Nor does Kholin's strange romantic game with Masha and the fleeting rivalry with Gal'tsev for her affections. This is not to say that the narrator Gal'tsev takes a more positive view of Kholin than his film counterpart; in both versions,

he clearly dislikes him. But Bogomolov's narrator
does not shy from describing the heroic details of
Kholin's death, saving his squadron from a German
ambush and detonating a grenade to kill himself and
his would-be captors. The film only informs us he
has been killed, but clearly remains on the mind of
Gal'tsev, who carries on a conversation with the dead
captain in the moments before the closing scene. It is
one of the more interesting points of disparity. While
the film never fully assumes the first-person perspec-
tive of the book, in some ways, it manages to delve
further into Gal'tsev's psyche than the character's
own narration will allow. His own identification with
Ivan and, to a lesser extent, Kholin is brought out far
more forcefully in the film through the visual connec-
tions it manages to trace.

There are a number of other significant compar-
ative details which emerge upon a consideration of
the book and the film. Certainly, not all information
from Bogomolov's original necessarily carries over,
but some elements from the book do seem to influ-
ence the composition of the characters in the film.
Despite the fact that it never assumes Ivan's perspec-
tive, the story provides significantly more informa-
tion about the boy's past, even if much of this is only
peripherally incorporated into the film. The name
Bondarev, as many viewers likely suspect, is actually
a code name. As Ivan tells Bogomolov's narrator at
their last meeting, his real name is Buslov. By the time
Gal'tsev meets the boy, he has indeed spent time in

the Trostianets death camp (as he states to Gal'tsev in the film) and we learn that his 18-month-old sister was killed in his arms. Neither this fact nor her age is given in the film version, although they would seem to be motivating forces in the boy's twisted psyche. As Gal'tsev learns, Ivan's father was killed on the first day of the war. His mother, however, is only described as missing and it is suggested that, if she does not appear after the war, Ivan will be adopted by Katasonov. The film, obviously, handles the situation differently by creating a distinct character from just a few vague lines in the original text. Since the mother only appears in the dream sequences, we are strongly encouraged to believe that she has indeed been killed but, echoing the some of the uncertainty of the book, we are given equivocal, differing versions of her death. Ivan never talks about her to the other characters who, consistent with their knowledge in the book, can only guess what has happened to her. Kholin's explanation to Gal'tsev in their conversation by the river is far from definite, but there seems to be less doubt in the film that the boy has lost his entire family.

2
Film Analysis

In the analysis that follows, the primary focus is on narrative dynamics and the deeper themes that run throughout the work. While there is, necessarily, some commentary on the various characters along the way, some initial words on these personalities will help provide a more complete picture for those less familiar with the film.

Characters

Ivan

Ivan represents something of a turning point in the characterization of children in Soviet cinema (see Chapter 1). As Josephine Woll noted, the typical traits of the child hero were thoroughly reworked in this figure, and the 'innocent child hero' typical of the Thaw films no longer seems to apply (2000: 140). From his early confrontations with Gal'tsev, Ivan conspicuously lacks the guiltless charm of younger war orphans in films like *The Cranes Are Flying* and *The Fate of a Man*, both of whom are taken in by surrogate parents. In fact, such precedents make the eventual fate of Ivan all the more striking, dashing the reflexive expectation that he would eventually be adopted. According to the usual pattern established by some

of the better-known films of the time, Ivan should find a suitable replacement for his missing parents in the older characters who live and work with him. The idea is teased out in several scenes only to be repeatedly frustrated; first in the unsuitability of Kholin and the loss of Katasonych, and finally in the death of the child himself.

Children certainly did die in Soviet war films, but Ivan's death is on a wholly different level than those which would serve as the rallying cries in Stalinist films. The loss seems more total and personal than the heroic, inspiring sacrifice of Gerasimov's *Young Guard* or Arnshtam's *Zoia*. Even Bogomolov's deliberately flat characterization reveals a new depth to the tragedy of Ivan and children like him. This is not something that escaped the notice of the film-maker. In fact, what initially attracted him to the character was that much of the child in Ivan is essentially dead long before his execution: 'He immediately struck me as a character that had been destroyed, shifted off its axis by the war. Something incalculable, indeed, all the attributes of childhood, had gone irretrievably out of his life' (Tarkovsky 1986: 17).

The evaluation of Bogomolov's hero in these lines also reflects just how much the depiction of children at war had developed in the decade that followed the death of Stalin. The yawning void in this child's life, which earlier would have been filled by a sense of duty to the motherland or party loyalty, remains an open sore in both the story and the film. Tarkovsky's

own additions to the story, particularly the nostalgic dream sequences and the illuminating conversations with Gal'tsev, underscore just how much 'had gone irretrievably out of his life' (Tarkovsky 1986: 17). At the same time, these changes heighten the tragedy by illustrating just how much of the child in Ivan still remains beneath the surface, and how much is lost when he finally disappears into the swamp.

And Ivan is still very much a child, still grasping at what remains of the life he had before it was overtaken by the war. He exhibits an especially acute form of what the Russian philosopher Vladimir Soloviev (1853–1900) called the 'unrealized ideal in tragedy, where the persons portrayed are themselves permeated by the consciousness of the intrinsic contradiction between their reality and that which should be' (2003: 78). Tarkovsky's expansion of the character and the delineation of these two separate spheres of his life create what nearly amounts to a double life. In the second dream, for instance, the camera creates the impression that the dream-Ivan at the mouth of the well is dropping his feather on the Ivan asleep at the bottom. As in *Nostalghia*, the feather suggests the presence of an angel, but here the focus shifts to yet another Ivan at the bottom reaching through a second surface of water, another layer of the child's consciousness. During the waking dream, this split continues and intensifies; it becomes increasingly clear as the film progresses that the boy we see within the dreams is not simply the memory of a child who no

longer exists (though this is indeed a stratum in his psychic constitution) but a deeper, perhaps unassailable dimension buried deep within the child soldier. Even when awake, Ivan craves affection and approval, but he is also impatient and even truculent with those close to him. In some unguarded moments, he still laughs and plays, but all impressions from the outside world enter his consciousness through the filter of the war and are coloured by his own devastating experience. Even at his most childlike, left alone in Gal'tsev's quarters, his imagination only conjures up images of terror, pursuit and, finally, vengeance.

And so the child Ivan is often hidden beneath a rough and dirty exterior, much like the rags and soot that form his disguise on the German side of the river. But this is not to say that his impatience and abrupt manner in dealing with Gal'tsev is simply an act or defensive mechanism, it is now very much a part of who he is. By the time the narrative begins, Ivan is a boy shaped by the war, fully adapted to the unique role the conflict has created for him. What is more, he is at least as driven and dedicated as any of his elder comrades, even to the point of harbouring professional scorn for those in his way.

Gal'tsev

Though often the object of this scorn, Gal'tsev is a mirror image of Ivan, figuratively and literally. Both are essentially children, cast by the war into situations and positions ill-suited to their years. Both are

eager to impress their superiors and keenly feel the disadvantages of their age. Calling the lieutenant a 'young officer' is almost an understatement; at 21, he is not that much older than the child scout. Yet despite Ivan's treatment of him as an inferior during their clashes, Gal'tsev does not lack for experience and is no stranger to loss (the knife he lends to Ivan, for instance, is a keepsake from a fallen comrade).

But of all the adult characters associated with Ivan, Gal'tsev's acquaintance with the boy is clearly the slightest. Ivan clearly loves Kholin and Katasonych; his attitude towards Gal'tsev, until nearly the end of the film, hovers only slightly above tolerance. Yet the narrative is constantly at pains to bring forth a more profound connection between the two. On an initial viewing, we can see how Ivan and Gal'tsev insist on being included in dangerous missions, how they both demand that they not be treated as children and confess to anxiety and strained nerves. Gal'tsev's anger at not initially being included in the mission across the river mirrors Ivan's at the prospect of being sent away from the front. Beneath this, there are even deeper links intricately woven into the structure of the text itself. Complementary images of Ivan and Gal'tsev are distributed throughout the film. Graphic matches of the characters, interconnected and strategically distributed sequences tying the pair further together, form a sophisticated thematic and structural principle which both holds the narrative together and progressively expands in significance.

As with Ivan in the earlier sections of the film, Gal'tsev quickly becomes a centre of narrative interest and a conduit through whom much of the story is told in many of the later scenes. Tarkovsky may have made considerable changes to Bogomolov's narrative presentation in his reworking of the story, but he rarely strays very far from Gal'tsev's perspective, and much of what we know about Ivan's life is made available through the mediation of the young lieutenant. Implicit in this adaptation is the pull the boy exerts on Gal'tsev. The latter never vocalizes his concern for Ivan in the journalistic manner of Bogomolov's narrator, but his worry comes to the surface in his repeated questions to Kholin and his anxiety over the boy's fate in the film's penultimate sequence, deep within the ruins of the Gestapo.

Kholin

Considerably older than Ivan and Gal'tsev, Kholin's maturity seems roughly equal. Despite his age, both Griaznov and Gal'tsev describe him as a child – opinions justified by his behaviour. But he is hardened by the war and, at least on the surface, more than slightly cynical. Most troubling, he is perhaps the only character in the film about whom serious ethical questions may be raised. Kholin's relationship with Gal'tsev occasionally borders on antagonistic, as he childishly bullies the younger officer with the weight of his superior rank and experience. He seems never to miss a chance to reprimand or tease him – save

for their initial meeting when he first arrives to fetch Ivan, or in the solemn moments when they sit quietly drinking after the final mission across the river. His interest in Masha is similarly difficult to understand. In a single scene, he teases the young woman into falling in love with him, only to beg her to leave. Masterfully executed, the scene is ambiguous at best. Is Kholin simply toying with the feelings of the medical officer only to quickly crush them, or does he eventually repress his own desires, knowing the affair could never succeed? Given his leering description of Masha to Gal'tsev, it would seem to be the former. But their final meeting just before the epilogue suggests that there is something more to his feelings, or perhaps the possibility he regrets his earlier actions.

In a sense, this could also be a projection of his feelings for Ivan; there is clearly a measure of regret and anxiety for the boy whom he sends off behind enemy lines. Theirs is the most troubling relationship of the film. Along with Griaznov and Katasonych, Kholin often acts as a father-figure to the boy, yet Ivan does not seem to see him in this light. The circumstances surrounding Ivan's return to service in the second half of the film are left murky but it is not unreasonable to suppose (given his insistence on absolute secrecy and the confession to Katasonych that the mission could earn them a serious reprimand) that Kholin is using Ivan without the knowledge of his superior, namely Griaznov. It is difficult to determine if he is cynically exploiting the child's

anger and natural camouflage, but knowingly exposing Ivan to such extreme danger (and we are left to assume this final trip across the river is the mission that ends with his capture and later execution) outside the regular chain of command essentially makes any mitigating factors in his decision irrelevant. At the same time, there is no doubt Kholin genuinely loves Ivan and is not at all at peace with what he has done.

Katasonych and Griaznov

For a war film, *Ivan's Childhood* adheres to an unusually tight circle of characters. Beyond Ivan, Kholin and Gal'tsev, only four are developed beyond vague descriptions and one of them, Ivan's mother, exists only in his dreams and memories. The two male characters at this level, Katasonych and Colonel Griaznov, are, more so than Kholin, cast as surrogate fathers to the boy and both are mentioned as possible adoptive parents following the war. Once again, any expectations on this score are dashed. Katasonych, an older and clearly experienced veteran, is perhaps the more likely candidate, given his obvious affection for Ivan and easily obliging nature. One of the most positive characters in the entire film, his death at the hands of a German sniper (he is the only character killed during Ivan's stay at the camp) marks an ominous turn of events just before the final mission across the river.

Griaznov, as the highest-ranking figure in Ivan's circle, has a more natural role as a father to the

child. Like Katasonych and Kholin, he cares deeply for the boy (witness his expression of joy and relief at Gal'tsev's report of the child's return) and, as far as the viewer can ascertain, has decided to pull him away from the fighting – enforced with the threat of a spanking should Ivan again try to run away and join the partisans. And this indeed seems to be the posture of their relationship. Griaznov's authority gives him the space to command Ivan in a way none of the other characters seem capable of doing, and his reprimands are consistently those of a parent or grandparent. Ivan's reaction, too, is one of a child to a parent; he appeals and pleads with Griaznov, but also stubbornly resists his commands.

Masha and Ivan's mother

Some mention has already been made of the backward treatment of women in *The Steamroller and the Violin* and Tarkovsky's later works. The characterizations are not as egregious here, but women in *Ivan's Childhood* are clearly on a lower plane than the men; but for the few scenes with Masha and a few lines from Ivan's mother in the second dream, they are scarcely given a voice. On the whole, this controversial aspect of all the films, though it does not necessarily spoil the director's oeuvre, does demand some extra patience or indulgence on the part of the viewer. It is tempting, given a number of statements made by the director in various interviews, to find a similarity between his views and Gal'tsev's explanation for

transferring Masha away from the front: art, just like war, is a duty and calling best left to men. In point of fact, however, this attitude comes straight from Bogomolov's novella and, somewhat surprisingly, Tarkovsky's retelling of Bogomolov's story expands the portrayal of women considerably. Masha's role in the novella is much smaller and both the mother (who merits only a mention in Bogomolov's tale) and the young girl who appears in Ivan's dreams are parts created solely for the film. Ivan's mother is of a much different type than Sasha's in *The Steamroller and the Violin* or, for that matter, any of the others featured in Tarkovsky's films. But since she is dead by the time the story begins, she is necessarily reduced to a projection of Ivan's consciousness, not entirely unlike Hari in *Solaris*. Unfortunately, this makes her a difficult character to approach analytically, other than acknowledging her as a kind of ineffable maternal ideal.

Masha gives us a bit more to work within her brief appearances. She is approximately the same age as Gal'tsev and, as the only woman in the real world of the film, an object of considerable attention on the Soviet side of the river. We learn that she is from Peredelkino, the Soviet writers' colony, has gone to college and is obviously smitten with Kholin. Yet, as Maliavina plays her, there is a degree of timidity and reticence that somehow detracts from her character. This is understandable in her relationship with Kholin and his aggressive advances but seems to extend to

her behaviour under fire as well, as she clumsily urges on the other medics venturing out into the German attack. This may be a justification of Gal'tsev's ultimate decision to send her away from the front, but as it stands, there seems to be little more to this character than there is to the mysterious and silent girl in Ivan's dreams, whom she so closely resembles.

Scene-by-scene analysis
The first dream

The opening moments of *Ivan's Childhood* are among the most distinctive in Russian cinema and a fitting prelude to the story that follows. Many of the sounds and images introduced here become leitmotifs that reappear throughout the film, often as direct repetitions, sometimes as dark inversions. A cuckoo is calling as the Mosfilm logo fades to a close-up of Ivan behind a tree, gazing through a spider's web. The boy moves out of the frame, soon reappearing in the background of a sunlit field, and the camera ascends to the top of the tree. Though Ivan is usually the central figure, perspective in this opening sequence shifts incessantly between objective positions and ostensibly subjective angles, such as the close-up of a tethered goat and the flight of a moth across the meadow. From this last image, the boy himself begins to rise above the trees and, cutting to another subjective angle, descends the side of a hill while a woman (soon revealed to be his mother) carries water from a well in the distance. Back on the ground, Ivan runs his

fingers over a wall of earth, glimpses the sun through the trees, and then runs to drink from the bucket his mother has placed on the sand. He lifts his head and excitedly tells her about the cuckoo in the forest, but as she raises a hand to wipe her face the sound of thunder, or gunshots, rolls over the soundtrack. The frame convulses with the sudden shock. The boy cries out and jumps awake to find himself alone in a creaking windmill.

Here, within the opening moments of the film, we see the first of many fractures that form the initially sharp division between dream and reality. As András Bálint Kovács and Ákos Szilágyi pointed out many years ago, the action of the film runs along these two distinct narrative planes; the diegetically real world of the war, and the dreams and fantasies of the boy (1987: 52). The Russian philosopher Igor' Evlampiev makes a similar case, finding both oneiric and realistic narrative planes operative in the film, both carrying an equal ontological weight (2001: 21). Indeed, the film is framed by and interspersed with incongruous, quasi-fantastic sequences that consistently disrupt the regular progression of the story. But beyond the obvious surface differences between the bucolic dreams and the reality of the war, the film also works to bridge this divide, frequently blurring the line between the real and the imaginary to a point of indiscernibility.

From a narrative standpoint, at least for the time being, the film assumes a markedly different

perceptual stance in the waking world of the war. Generally speaking, identification with Ivan's perspective is strongly encouraged within the dream sequences; much of the world is seen through his eyes and the very fact that we see the dreams suggests penetration into his consciousness. To borrow the language of the American critic and narratologist Seymour Chatman, the dreams offer classic examples of perceptual filtration, instances where sounds and images are relayed to the viewer 'as *if* the narrator sat somewhere inside or just this side of the character's consciousness and strained all events through the character's sense of them' (1990: 144, original emphasis). By contrast, particularly in these early sequences, narration in the waking world of the film often lingers several steps from the protagonist, with occasional shifts into his perspective as a brief reverie or the prelude to a dream. As the story progresses, however, these variations in attachment to Ivan become much more complicated and significant.

The differences between the oneiric and realistic planes are immediately palpable in the very next sequence. As Ivan exits the windmill and makes his way across the ruined landscape, we are again presented with several shots of him looking but, unlike the opening dream, there is no assumption of his perspective and only gradually, as the scattered bodies and ruined machinery come into view, are we given clues to the reality of his situation. What the child is doing out in such a place alone, slinking through the

barbed wire while flares pop overhead, as yet remains a mystery. Like many other questions raised in the film, information on Ivan and his past comes to the viewer largely through the mediation of the second major character, Lieutenant Gal'tsev.

Gal'tsev's headquarters

The credits roll as Ivan swims across the Dnepr to the Soviet side of the river. The next sequence opens with the sleeping Gal'tsev shaken awake to the news that a boy has been detained by his soldiers. His interrogation and Ivan's sharp replies quickly establish the film's second centre of interest. In many respects, the film is as much about this young officer as a witness to the war as it is about Ivan. As the story develops, Tarkovsky's narrative system increasingly relies on the presence of Gal'tsev to both relay information to the viewer and provide a narrative anchor for scenes in which Ivan is absent.

At this point, however, the interrogation helps to establish an initial sense of identification with Gal'tsev. As we are naturally interested in the same questions he asks the boy (Who are you? What were you doing on the other side of the river?), a sense of viewer identification with the lieutenant is quickly established. And it is only as the answers to his questions gradually surface that the events of the pre-credit sequences begin to take a coherent shape: Ivan is a scout returning from a secret mission behind enemy lines.

Figure 2.1: Ivan in the swamp.
Still from *Ivan's Childhood.*

Further interrogation is met with harsh dismiss-
als as Ivan demands to be put in contact with his
superiors. Gal'tsev relents and the scene momentar-
ily shifts to the headquarters of Colonel Griaznov,
the local chief of military intelligence. Gal'tsev is
ordered to provide the child with the means for
making his report, but on his own initiative offers
a bath, food and a bed. As he busies himself with
the accommodation, Ivan sits down to work, and
the next shots once again take us into the mind of
the child as he counts out the various berries, nuts
and pine needles representing the German units

occupying the other side of the river. Gal'tsev's shuffling in the background is absorbed into the sound of troops on the move, aural fragments of the boy's memory pushing into the real world of the present. Though brief, this short integration of past and present, or realistic and fantastic, plants a seed that continues to grow throughout the film. The intrusion of memory into the present moment here is but the first step in a carefully developed series of interactions. As in the later instances, the initial encroachment of the dream world on physical reality is signalled by a shift into the character's perspective. Here, like the first moments of the boy's waking dream later in the film (and a similarly dark reverie experienced by Gal'tsev in the penultimate sequence), the interplay is initiated by what the child hears. In the later scenes, this synthesis of the physically real and the ethereal shards of memory forms a pivotal aspect of the film's presentation of consciousness and temporality. This extends to the oneiric sequences, which are not simply the nostalgic musings of the sleeping child, nor the direct, fragmented memories of a shattered innocence. Rather, they stand out as a kind of catalyst for the full integration of the physically real and the immaterial world of mind and spirit.

The second dream
The fringes of the full dream sequences are marked by similar transitions into the child's consciousness.

Shortly after swallowing a single bite of the meal provided by Gal'tsev, the lamp before Ivan begins to sway and fall as the camera slides into his perspective and the boy nods off. As Gal'tsev carries the sleeping child to bed in near silence; it is as if the second dream sequence has already begun. Dripping water somewhere in the room coalesces into a dream image of drops falling from the child's hand and, eventually, into the bottom of a well as the structure of the room becomes distorted and dream fully envelops reality. From a close-up of the hand, the camera moves up the wall to Ivan and his mother looking down from a sunlit spot at the mouth of the well. Foreshadowing the waking dream later in the film, the boy seems to have literally split along the two sides of reality.

Mother and son gaze into their reflections at the bottom of the well as if staring into a mirror and perspective shifts from a classic point of view (POV) shot into a seemingly more objective angle of the two discussing what they see at the bottom. As Ivan reaches down to touch the star indicated by his mother, he somehow breaks through the surface of the water and, in an instant, moves invisibly to the bottom of the well. This breakdown of spatiotemporal continuity, so common in Tarkovsky's later films, would appear to be motivated by the oneiric logic at play in the sequence; unlike the later films there are few, if any, breaks in the sensory-motor schema outside of these dream sequences. Here, as with the manipulation of perspective, the collapse of logical spatiotemporal

coordinates draws a sharp distinction between the worlds of dream and reality – at least for the moment. Within what appears to be the subjective world of the child's mind, notions of time and space become as fluid as the liquid mirror into which the two characters stare. Once again, the tranquillity of the dream is abruptly broken. A German voice is heard on the soundtrack, the sound of a shot rings out and the bucket raised by the mother plummets to the bottom, narrowly missing the boy's head. Illogical continuity carries over into the next shot as water splashes over the mother's body, while the full bucket now sits at the edge of the well. Like the first dream, the second has ended with what appears to be her death, but now we move back into the waking world by again looking through the child's eyes. Gal'tsev hovers over him, holding the lamp that signalled the entrance to the dream.

The addition of these sequences is the most substantial change Tarkovsky made to Bogomolov's narrative, but by themselves the two early dreams provide little specific information about the child and his history. They do, however, contain fragments from which the viewer may construct a more general picture of the character at the centre of the film. These are not, strictly speaking, memories, as Ivan's mother appears to have perished in two different ways at the conclusion of the first two dreams; nor, as we will examine in greater detail below, are these simply the subjective fantasies of the young protagonist. At this

66

stage of the film, they have already established a second, alternative reality within the world of the story where the 'monstrous child' described by Sartre is again, if only for a moment, simply a boy and not yet the sullen, embittered child soldier creeping through enemy lines and precociously barking orders at the flustered Gal'tsev (Sartre 2008: 39). The arrival of Captain Kholin soon after the conclusion of this second dream marks the first time the child of the dreams appears in the real world. At the sound of his name, Ivan immediately reverts from the angry scout to a young boy obviously starved for affection and immensely pleased at the arrival of his friend. With the third of the three major characters now in place, the scene briefly shifts away from Gal'tsev and follows Ivan to the office of Colonel Griaznov.

Griaznov's headquarters and Ivan's flight
Although he is only off screen for a few moments, the transition to Colonel Griaznov is the first noticeable break in narrative attachment to Ivan. As the scene inside Griaznov's command centre opens, the colonel is giving orders into a telephone with Ivan's report in his hands; obviously the new instructions are based on information the boy has provided. Katasonych enters, having spent the previous night waiting for the scout on the other side of the river. The conversation immediately turns to Ivan, who soon bursts into the room and loudly protests the decision to send him to a military academy in the rear. Considering his heated

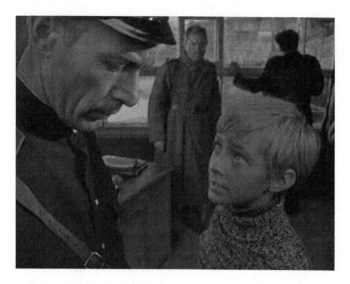

Figure 2.2: Ivan and Griaznov.
Still from *Ivan's Childhood*.

pleas and accusations, it is clear the plan has just been revealed to him. Moreover, the bearer of the information has been Kholin, who sheepishly follows the boy into the room. Griaznov is unmoved and Ivan quietly declares his intention to join the partisans, a threat carried out in the very next sequence.

His eerie meeting with an old man amidst the ruins of a scorched wooden house (*izba*) presumably occurs later that same day. The scene was singled out by the film-maker in *Sculpting in Time* as one of the least successful sequences of the film. Dissatisfied with its 'plastic realization', Tarkovsky later expressed regret over not sticking with a different version of

the encounter, in which their meeting was to take place in a cart moving along a muddy autumn road (Tarkovsky 1986: 31). The regrets are not surprising, as the scene is certainly not representative of Tarkovsky's more mature work, particularly with regard to shot duration and some of the more patently melodramatic elements, such as the old man's rhetorical question of 'when will it all end'. But the sequence nevertheless fits quite well within the general tendencies of the film as a whole, marking another stage in the progressive interpenetration of oneiric and realistic narrative planes. The surreal atmosphere almost seems to fuse dream and reality as the boy listens to the old man anticipate the arrival of his dead wife and helps sift among the ruins of his home for a nail he equates with the German soldier who killed her. Their conversation confirms what the dreams have already suggested: Ivan's mother has been killed in the war. The circumstances of her death are never revealed, but the old man guesses the cause ('a German shot my old lady too'), and the film makes an explicit (though brief) reference to the previous dream by flashing to a well standing just outside the house. As will be the case with Ivan a little later, the old man has difficulty distinguishing fantasy from reality, presumably the effect of a similar trauma. Though his wife is dead, he continues to organize the ashes of his home in preparation for her return. The shot of the well underscores a link between Ivan and the man as well as the integration of fantasy and

reality, while a burned tree standing nearby grimly foreshadows the final image of the film. With shots moving in rapid succession (at least for a Tarkovsky film), the car carrying Griaznov, Kholin and Katasonych arrives, and the dreamlike atmosphere dissipates into a more regular shot rhythm. The car pulls away, but it stops for a moment at the well where Ivan leans from the window to leave some food for the old man. The trip back to Griaznov's headquarters continues the previous argument, with the colonel determined to send the child away (threatening him with a spanking) and Ivan equally determined to stay. This first act of the film closes with haunting images of the ruined landscape taken from the moving car.

Masha

Until this point, Ivan has only been off screen for, at most, a few minutes and has always remained the topic of conversation for the other characters. His absence following the aborted flight from Griaznov, however, signals a fundamental organizational shift in the film. The boy is not only absent, he is not even mentioned for more than ten minutes of screen time. In his place, the film introduces the only significant character with whom he has no contact. The medical officer Masha never meets him nor do the other characters ever mention him in her presence. And yet, in his absence, she occupies a position similar to that of Ivan vis-à-vis Kholin and Gal'tsev, both of whom seem to be vying for her affections.

The first of the three sequences involving Masha begins *in medias res* as a posturing Gal'tsev delivers an officious reprimand, employing the same tone initially used in the meeting with Ivan. Kholin soon steps into the dugout to take him on an inspection of the fortifications, and the scene shifts to a flashback of Kholin and Masha meeting for the first time in a birch forest. The move is something of an anomaly within the context of the film. *Ivan's Childhood* is easily among the most linear of Tarkovsky's films, even with the dreams occasionally disrupting the flow of the story. But now it unexpectedly makes a disorienting move at least several hours back in time. Here, in

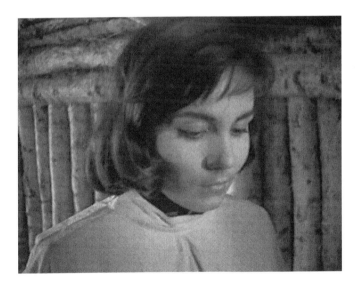

Figure 2.3: Masha.
Still from *Ivan's Childhood*.

71

the forest, both Kholin and Masha are now in dress uniform and obviously meeting for the very first time. Unlike the traditional flashback, this sequence does not seem to be connected to the memory of any one character. In fact, at various points, all three appear in this scene, without the camera seeming to favour any of them. To this point, memory in the film has been connected solely with Ivan. With him off screen, it is as if the narrative loses stability in terms of its attachments as well as the temporal presentation of events. But this instability may actually be indicative of a larger, more impersonal form of memory intruding into the diegetic present and, thus, a prelude to the film's even more enigmatic epilogue.

The move enables the fledgling relationship between Masha and Kholin to stand out all the more sharply from of the rest of the film; it carries a hushed romantic intensity rarely found in Tarkovsky's later works. With the exception of the woodpecker (an echo of the cuckoo earlier) and the quiet voices of the characters, the scene is nearly silent. Looking ahead to the meditative sequences of the director's later films, it is the sound and the silence of the forest itself, of life unfolding as usual, that dominates the aural track. As they move among the trees, Kholin challenges Masha's bravery by daring her to walk along the trunk of a fallen tree and then grasps her as they step across a trench, into which the camera now descends. In perhaps the most famous shot of the film, the captain steals a kiss while straddling

both sides, and shots heard in the distance silence the woodpecker. Time, for a moment, now comes to a halt as she remains suspended in his arms. For Peter Green, this is essentially 'a kiss by the grave', in reference to the fate awaiting Kholin later in the film (1993: 29). Evlampiev sees it as an illustration of the impossibility of romantic love taking firm root in a world destroyed by the war (2001: 32). Kholin himself may intuitively grasp the impossibility of the situation, the futility of romance in the middle of the war, and unexpectedly sends Masha away. Or perhaps it is all part of a game, and he is simply playing with the emotions of the young medical officer. The vaguely licentious description of Masha he gives to Gal'tsev in the next scene may support this and underscores Kholin's moral ambiguity in a film genre where (at least in the Soviet Union) the lines between good and evil are seemingly well established. But the earnest manner in which he speaks to her during their final encounter later in the film reveals a different shade to the character and parallels perhaps his loving, yet clearly exploitative, relationship with Ivan. Kholin, despite his masculine posturing before Gal'tsev and Masha, is never a man at ease with his situation.

Though he does not take part in the dialogue in the forest, Gal'tsev is not entirely absent from the scene. Just before Masha is challenged to climb the tree, there is a cut to the periphery of the forest where Gal'tsev questions the soldier Vasil'ev on

her whereabouts and then hurries off to interrupt the meeting with Kholin. In a single shot, the film transforms Bogomolov's Gal'tsev, a stoic young lieutenant aware of the charms of the medical officer but, in this time of crisis, able to dismiss them, into a character, not unlike Ivan, whose youth and vulnerability occasionally break through the thin façade. He arrives too late and his disappointment is clearly marked by Kholin, who casually suggests they inspect the fortifications. Here the film leaps ahead to the conclusion of the previous scene. It is in the interval (and after all of them have changed their clothes) that the scene in Masha's dugout has taken place. Gal'tsev, perhaps to alleviate his frustration over her having met with Kholin in the forest, has stopped by to deliver the complaints and reprimands with which these sequences began.

The promised inspection takes place as the two officers, again dressed for combat, join Katasonych in the 'metro'. As Kholin looks through the periscope to the other side of the river, the camera now takes on his perspective (one of the few times in the film it will do so) as the bodies of the two scouts, Liakhov and Moroz, come into view. For the moment, the full reason for this inspection remains obscure. Only as Gal'tsev guesses at the nature of Kholin's visit is the audience made aware that a new mission across the river awaits Ivan. How he has persuaded his superiors to keep him at the front is left a mystery to Gal'tsev, who tries in vain to glean more information from

Kholin. But considering the latter's secrecy (even when Gal'tsev is included in the mission) and the fear he later expresses to Katasonych of the higher ranks finding out about the mission, it is safe to assume the crossing is done on Kholin's own initiative, that Griaznov does not know the boy is again being used to reconnoitre the German positions in preparation of the coming offensive.

As the scene concludes, there is a return to Masha, who is standing in the path of the soldiers as they leave the trench. She is approached by an old school-mate (played by Konchalovsky) and answers him distractedly as Kholin passes. And here an especially interesting mix of perspectives takes place. We are clearly within Masha's gaze as she affectionately watches Kholin depart and within her thoughts as a waltz plays over the soundtrack and she dances alone in the forest. From swirling trees and a shot of her spinning to the music, there is an unexpected cut to Kholin's perspective in the previous scene as the bodies of Liakhov and Moroz come back into view. Thematically, the motivation for the shot is clear enough: death waits on the other side of the river. While it is tempting to see this as a rhetorical flourish on the part of a young film-maker still finding his artistic bearings (as Tarkovsky himself would later describe it) this move, particularly in the mixing of different subjective angles, sets another precedent, which continues to develop over the course of the story. It is the first of several instances where the film

engages in a kind of multiple filtration by ascribing the perspective of a shot, or the aural qualities of the soundtrack, to the perception of more than one character. As the narrative attachment to Ivan, which was so strong in the first part of the film, gradually begins to weaken and gravity begins more and more to shift over to Gal'tsev the film, with increasing frequency, will mingle the perception of one character with that of another. These fused perspectives are critical to the overall structure of the film and, in particular, the final sequences. In the end, one of the more striking features of *Ivan's Childhood* is this subtle synthesis of differing perspectives and the deliberative development of these techniques over the course of the film.

Preparations for the mission
When Ivan returns to Gal'tsev's quarters in the next scene, there are already some slight changes in the presentation of the characters. Now, though the camera largely remains attached to Ivan, it is conspicuously divided between him and the young lieutenant. Increasingly, the audience knows only what Gal'tsev knows and, consequently, at this point in the film, much of the child's story and plans for the immediate future remain a mystery.

The return of Ivan, Kholin and Katasonych to Gal'tsev's quarters marks a conspicuous and rather disruptive ellipsis in terms of story information. The film reveals nothing of what has happened since Ivan was brought back, but we soon learn (as Gal'tsev

eavesdrops) that Kholin and Katasonych are planning another mission across the river. How Ivan came to be involved and how (or if) he persuaded Griaznov to let him stay remains a secret from the lieutenant (and the audience) for the remainder of the film. Johnson and Petrie have ascribed this and similar gaps in the story to Tarkovsky's 'apparently offhand attitude to imparting crucial fabula information' (1994: 77); but, in fact, this restriction is in keeping with the controlled, evolving system the film-maker has put in place. Staying within the realm of Gal'tsev's knowledge keeps the film at least superficially consistent with Bogomolov's original story (of which, we recall, Gal'tsev is the narrator) but it also allows the insertion of a new thematic dimension. Beyond merely telling the story of the young scout and his exploits, Tarkovsky's Gal'tsev serves as the focal point for actively engaging the audience in pursuit of a deeper understanding of the child. As Denise Youngblood has observed, 'Galtsev serves as the picture's moral center', and it is partially through this centre that the inner life of the child, first glimpsed in the early dreams, is revealed (2007: 126). His position is far less explicit than Tarkovsky's later protagonists, yet Gal'tsev is at the centre of the film's search for harmony or some kind of spiritual value in the midst of the war's chaotic destruction. It is largely with this quest and the revelation of a deeper reality through the medium of the dreams that the film-maker fully makes Bogomolov's story his own.

For now, Gal'tsev's presence in the scene reveals considerably more about the child's life during the war. Fragments of Ivan's past emerge almost incidentally while he and Gal'tsev look over a book of Albrecht Dürer's engravings. As he turns the pages and moves from picture to picture his experience of the war continues to unfold. Stopping at the print *The Four Horsemen of the Apocalypse*, the boy equates the images to actual people, victims and aggressors, even singling out a skeletal rider for his resemblance to a German soldier. The focus on this picture and the direct connection the boy makes between Armageddon and the war as he himself perceives it provides a powerful and unambiguous introduction to the eschatology that darkly overshadows each of Tarkovsky's films. At the same time, the brief pause over the famous images is something we see replayed again and again in these works, as if imploring the viewer to take another, deeper look at the great visual works to which we have all too often become inured. The next print, Dürer's *Portrait of Ulrich Varnbühler*, inspires a more detailed recollection. To Gal'tsev's distracted description of the image being a doctor or writer, Ivan responds that there can be no German writers, that he had personally witnessed a book burning in his village square, where the ashes had hung in the air for a week. Perhaps more important here, however, is the way the film-maker once again fuses perspectives, this time those of Ivan and Gal'tsev. As Ivan speaks the camera tracks his gaze, following the signals given

by his off-screen voice and pausing on the figures of the riders and their victims as they are mentioned. These images, however, are intercut with shots from Gal'tsev's perspective as he listens in on the conversation between Kholin and Katasonych going on across the room. A critical movement occurs just a moment later during an unobtrusive cut in which Ivan turns to the *Portrait of Ulrich Varnbühler*. Following a shot of both Ivan and Gal'tsev looking at the page, their discussion continues over a close-up of the image, a suggestion that we are now seeing a combination of perspectives. The shot is primarily imitative of Ivan's gaze but Gal'tsev's voice, discussing the subject with the boy, indicates that this is also a refraction of his point of view. This fusion of their perspectives, still at an initial stage of development, will prove decisive in the latter half of the film.

On the other side of the room, Kholin and Katasonych discuss retrieving the bodies of Liakhov and Moroz. There are also indications of a coming offensive and Ivan's presence suggests there will soon be more reconnaissance work. At this, Gal'tsev, who has been listening in since the beginning, asks to be included in the mission. Kholin again starts teasing the younger officer and tensions rise as they start to argue over the boats hidden at the side of the river.

The antagonism spills over in the next scene as the three men (leaving Ivan alone in the church) approach the river to inspect the boats. Here, in the conversation between Kholin and Gal'tsev, we finally

learn more specific information about the boy's past:
in addition to his mother, Ivan lost both his father
and his sister earlier in the war. Neither of these char-
acters has yet appeared in the dreams. In response
to Gal'tsev's persistent questions, Kholin muses that
after the war Ivan will be adopted, either by Griaznov
or Katasonych. The possibility that he himself take
guardianship of the boy is brushed aside; Griaznov
has said that the captain himself has a lot of grow-
ing up to do – a sentiment shared by Gal'tsev as the
quarrel becomes more heated and the scene comes
to a close.

The waking dream
Chronologically coincident with the argument on the
Dnepr, the scene of Ivan alone in the empty church is
one of the most powerful and intricately orchestrated
of the film. It is also an important transition point in
terms of story and narrative structure. Thus far, the
dream sequences have been signalled as such by shots
of the character falling asleep or waking up. Here
there are no such indicators but clearly the bizarre
sounds and images that dominate the sequence have
their origins in the realm of dream or memory. The
two narrative planes, which have hitherto divided the
film, now openly converge as the boundary between
dream and reality is erased in the child's mind. And
the emphasis on his consciousness, the adroit manip-
ulation of his perception in this scene is of particu-
lar importance. At several points during this waking

dream, the narrative covertly mimics the child's perspective, making it extremely difficult to tell if shots, even those with Ivan himself in the frame, actually present an objective angle. The audience is thus placed in a position somewhat analogous to the character, unable to determine if the images are fantasy or reality.

Ivan raises the bell first glimpsed a few moments earlier in his conversation with Gal'tsev and crawls across the floor in imaginary pursuit of a German officer. Here, in his most childlike moments, Ivan is still unable to escape the larger tragedy around him. Even his games necessarily involve war and revenge. These more objective shots shift immediately as a voice speaking in German fills the room. The sound, so pervasive in this sequence, marks the entrance into the boy's consciousness, the opening move into a quasi-subjective narrative position upon which the presentation of the entire sequence hinges. Despite the fact that these noises are obviously coming from Ivan's mind (and recall the earlier scene of him writing the report), his initial reaction is one of surprise and alarm, as if, like the old man encountered earlier, he can no longer distinguish the reality before him from the sudden irruptions of fantasy or memory. In an instant the simple game of war has become something more serious. He looks about with a flashlight, searching the walls and corners of the room to find the source of the sounds. The next shots delve deeper into the child's mind as the camera now follows

the light, the focus of his gaze. As with the dream sequences, there seems to be an alternation between his perspective and objective shots with him in the frame, but here the distinction fades - Ivan is also marked as the subject of his own gaze. Several clues strongly suggest that within this waking dream the boy is actually seeing himself. Following the motion of the flashlight as it moves across the room, the camera comes to rest on the message scrawled by a group of youths awaiting execution. The writing appeared briefly earlier, during the first meeting with Gal'tsev, and now comes fully into focus when illuminated by the flashlight: 'There are eight of us, each no older than nineteen. In an hour they will execute us. Avenge us!' While the light is moving over the writing, Ivan suddenly steps into the frame, facing the message on the wall and reading along as the beam of light continues to scan from a space behind him. Still tracking the boy's gaze, the camera (following the flashlight) again begins to fly about the room as the victims weep and moan over the soundtrack. In quick succession, we move from Ivan (Figure 2.4) to a figure lying on the floor (perhaps Kholin). The light moves back to Ivan as he makes his way to the mirror near the entrance and then jumps away to find the familiar figure of the mother huddled against the wall. Ivan is now shown standing at the mirror, facing the camera with a dagger lent to him by Gal'tsev raised in one hand and the flashlight in the other. Moving away, both Ivan and his mother briefly reappear in the

frame but quickly the camera descends into a low-angle shot of the bell. There is then a reverse-angle cut in which Ivan rises from a position corresponding to the perceptual angle of the previous shot – at the other end of the room from his previous position before the mirror. Thus, the film encourages us to understand that everything that has just come across the screen, including the images of Ivan standing before the mirror and the message on the wall, has been relayed directly through the eyes of the child.

He approaches and rings the bell, dispersing the German voice and sounds of sobbing that have dominated the soundtrack. Now the cheers of victory can

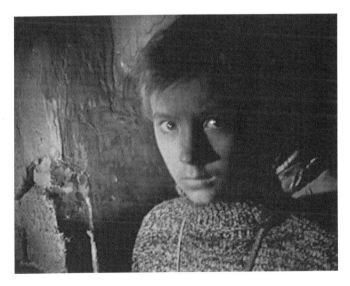

Figure 2.4: Ivan in the flashlight.
Still from *Ivan's Childhood.*

be heard along with the ringing of the bell, the same tracks to be used later in the transition to the epilogue. But as with the sobbing and the German speech, these sounds take on a life of their own, outside of his control. Ivan releases the bell after only a few seconds, yet it continues to ring as it hangs motionless. As before, the child seems startled by the sound but here joins in with the cheering as if the game (and the war) has been won. The next shot, however, resumes the grim tone and Ivan, having caught the imaginary officer he pursued at the beginning of the scene, confronts an empty coat hanging on the wall. In the end, this game proves to be impossible. Directing his anger and threats at an empty space, Ivan can only finish by collapsing into tears.

As a demonstration of the extent to which the child has been shattered by the war, this is perhaps the most effective scene of the film. By burrowing into his consciousness, making the most of the sounds Ivan hears and the images he sees, the viewer is given a glimpse of the boy looking deeply within himself, confronting the memories which continue to dominate his waking moments and suggesting perhaps his own understanding of the futility of using revenge to restore any kind of emotional or spiritual equilibrium.

But this is only for a moment; just as Ivan begins to weep, an explosion bursts through the door, loudly announcing the continuing presence of the war outside. At this point the film, rather than remaining with the child, loses itself for a few moments in the fear

and confusion of the German bombardment. This is the closest *Ivan's Childhood* ever comes to a battle scene and the chaos is duly represented as we rapidly move from images of Gal'tsev's boats being smashed to characters huddling together in trenches. Gal'tsev hurries through the encampment, Masha urges on medics as the walls are shaking around her, and the old church buckles under the bombs. The location gives the director the opportunity to linger on religious imagery. With the shells falling the camera pauses on a fresco of the Virgin and Christ and then, as Gal'tsev finally reaches Ivan, a cross in the churchyard. First from a canted angle, the image appears to tilt as the camera straightens and becomes still as the sounds of the shelling fade and are slowly replaced by birds singing in the distance. The camera lingers for a moment as the dust settles and the sun slowly peeks through the smoke. The suspension of action is somewhat reminiscent of the kiss between Kholin and Masha, as the film asks the viewer to pause and simply contemplate the image on the screen.

Confronted with such a universally recognized symbol, it is tempting here to find a logical connotation with the events in the story, perhaps a counterpoint to the inhuman catastrophe of the war or something eternal outside of the reality on the screen. Certainly, the film-makers were aware of the varying responses such an image would generate; it does seem designed to provoke an emotional reaction. And this would hardly be difficult for a Soviet audience viewing the

film in 1962, when this focus on the cross, a shot which ten years earlier could have easily landed the director in prison (if not worse), would have had a surprisingly powerful effect. But just as important is how the shot produces a sense of 'time-pressure' as the image inexplicably lingers on the screen after the bombardment (Tarkovsky 1986: 117). This sensation of time, particularly evident as we begin to notice the pause in the story, is arguably the most defining and striking characteristic of Tarkovsky's later films, as the basic 'observation of life's facts within time, organized according to the pattern of life itself, and obeying its time laws' (Tarkovsky 1986: 68).

The third dream
Ivan reveals more of his story to Gal'tsev as the two clean up following the bombardment. As we already know, Ivan has spent time with partisans, but he adds here a few details of his life in the rear, which he regarded as a useless waste of time. It also comes to light, as the boy heatedly reacts when Gal'tsev suggests he attend a military school, that Ivan has spent time in Trostianets, an extermination camp outside Minsk that saw the deaths of over 200,000 people.

Several hours seem to pass between this scene and the next. It is dusk by the time Kholin slowly makes his way to the church. His chain-smoking and pensive mood in these shots outside (one of the few times he is ever pictured alone) are in keeping with the natural anxiety of a dangerous mission, but we soon learn

there is even more on his mind. By the time Kholin joins Ivan and Gal'tsev, the debris has been cleared away and Ivan takes a moment to chastise the captain for his smoking habit. The three sit down to a final meal before the mission and, to the clear dismay of Ivan, Kholin announces that Katasonych has been summoned away, feigning his own annoyance at the disruption to their plans. Gal'tsev is to take the older soldier's place and, for good measure, endures yet another dressing-down from the captain. Kholin's excuses do little to comfort Ivan; after hearing the news, he leaves the table while the two officers continue to discuss the impending expedition. Once again, the camera tracks Ivan's gaze along the ceiling, pausing once again on the message scrawled into the wall, and gradually fades into the next dream.

Ivan's third dream is markedly different from those that precede it. His mother is conspicuously absent, as is any camera angle approximating the boy's point of view. And while there are certainly ominous signs in the negative images of the thunderstorm that flashes in the background and the successive images of a little girl's smile gradually fading, this is easily the most benign of the oneiric sequences. It opens with Ivan riding through the rain in the back of a truck overflowing with apples. With him is a young girl who, despite being approximately the same age as Ivan, bears a remarkable resemblance to Masha. Drenched in the falling rain but obviously enjoying the ride, Ivan offers the girl apples as the camera

Figure 2.5: The girl in the dream.
Still from *Ivan's Childhood*.

tracks right and she is revealed in three different phases. Initially, she is completely soaked but laughing as the boy presents the fruit. In the next, the rain has abated but the laughter reduced to a smile. The final shot of the series shows her completely dry save for a few drops on her cheeks (perhaps tears) and a dark, even solemn expression.

The final shots of the dream are less expressionistic, but stand out in their pastoral serenity. The truck spills some of its cargo on the beach and several horses approach and begin to graze the apples. Rather than re-join the hero, the narrative remains

with these figures and Ovchinnikov's soothing score. As Tarkovsky later explained, the final shots on the beach are used to link this dream with the one that closes the film (1986: 31). While this may be the case, the beach and the river have already figured in the dream sequences as much as they have in the waking world. In the first oneiric sequence, it is distinctly part of the background and, though the river does not appear in the second, the aerial shot in the first situates the well very close to the water. In all four sequences, Ivan is dressed for the beach.

Much like the second dream, the return to the waking world here is signalled by a glance through the child's eyes as he awakens. This time it is Kholin standing before him, waking him up for the mission. The camera moves to detail the wretched clothing that serves as the boy's disguise on the other side of the river and the irregular rations being prepared by the captain. Sitting a moment before embarking on the journey (an enduring Russian custom), Gal'tsev clumsily breaks the silence by starting the phonograph (repaired by Katasonych during the scene over the Dürer album) and earns yet another angry rebuke from Kholin. The camera rests on Ivan as the message on the wall again comes into focus.

Crossing the river
It is dark by the time the three set off on the mission. The cross shown during the bombardment comes back into view as they make their way to the river.

89

Kholin sends Gal'tsev to distract a sentry (Ivan's presence in the camp is a secret to everyone but the two officers) and the lieutenant accidentally discovers the body of Katasonych. As the guard explains, Katasonych (he mistakenly calls him 'Kapitonych') was hit by a sniper, or perhaps simply a random shot across the river. Kholin was present and insisted that the death be kept quiet. We now know the real reason for his agitation in the previous scenes.

Once across the river, Kholin briefly disappears to clear the path for Ivan and the camera remains with the boy and Gal'tsev. Upon his return, the three bid their final farewells and Ivan disappears into the darkness. The moment marks a penultimate stage in narrative progression. While initially attached completely to Ivan, attention, as we have seen, begins to shift between the boy and Gal'tsev about midway through the film. Here, when Ivan finally disappears from the story, the narrative attaches itself completely to Gal'tsev, behaving much as it did with Ivan by staying primarily within the bounds of his knowledge and occasionally employing POV shots to imitate his gaze. In fact, both editing and camera movement seem designed to emphasize the shift (and foreshadow the epilogue) upon Ivan's departure by subtly ascribing his perspective to Gal'tsev. Close-ups of Gal'tsev looking are intercut with tracking shots moving over the still water of the swamp. The latter would seem to be taken from Ivan's perspective as he makes his way through the darkness, as would the

flares streaming overhead, but the editing creates the impression that Gal'tsev, who remains staring out from behind a tree, is the one looking.

Now alone, Kholin teases Gal'tsev for his nervousness (a trait he shares with Ivan) and his youth, but half-jokingly admits that he, too, would much rather be back home with his mother. Following the retrieval of Liakhov and Moroz, the two complete the perilous journey back to the Soviet side, jumping into the water to avoid bullets along the way. Back in the church, they sit quietly as Masha enters to say goodbye; Gal'tsev has had her transferred to another post away from the front. But just before her entrance Kholin has turned on the phonograph and Feodor Chaliapin's voice fills the room. The song, 'Masha is Not Allowed to Cross the River' ('Ne veliat Mashe za rechen'ku khodit''), resonates powerfully with the story and the revelation of Gal'tsev's decision. Even more telling is that when she abruptly departs, the record skips at the phrase 'crying eyes' (*zaplakany glaza*) and then begins repeating the word for eyes. Given the emphasis the film has placed on perspective, and the frequent use of subjective camera angles, the words are especially significant. Kholin turns to stop the record and remarks on the strange silence as the war continues to rage outside. He grasps the bell suspended from the ceiling earlier by Ivan, but releases it and, in a sudden fit of frustration, flings a stool across the room. The sound of the bell, as in Ivan's waking dream, nevertheless resonates over the

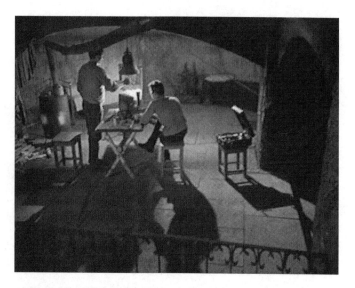

Figure 2.6: Kholin and Gal'tsev.
Still from *Ivan's Childhood*.

soundtrack, as do the sounds of cheering when the
scene cuts to documentary shots of Soviet soldiers
entering Berlin.

Berlin
While the central action of the film is concentrated
within just a few days, the transition to the epilogue
leaps ahead approximately a year and a half, from the
fall of 1943 to the spring of 1945. Perhaps the great-
est difference between these sequences and the rest
of the film – and what seems to set this section apart
as an epilogue – is not just the time elapsed but the

insertion of the documentary footage. The epilogue begins with archival material. But gradually these documentary shots give way to Tarkovsky's footage, still intercut with actual scenes of Berlin from 1945, and finally into Ivan's last dream.

The narrative anchor for the epilogue is Gal'tsev. As we soon learn, he is the only one of the main characters to survive (though we learn nothing of Griaznov, we may assume that, as in Bogomolov's story, both he and Masha make it through the war alive). With the disappearance of Ivan in the middle of the last section, narrative attachment has completely shifted to Gal'tsev, whose position is now fully consistent with that of Bogomolov's first-person narrator.

But Gal'tsev is not even shown until several minutes of the epilogue have already passed. The film takes us through the grim ruins of the German capital, pausing on bombed out buildings, the bodies of Joseph Goebbels and his family,[11] as well as the gruesome results of another murder–suicide in the home of a German officer. It is in the last scene that fact and fiction begin to overtly correspond; the jacket of a dead officer hanging on the wall unmistakably echoes the empty coat of Ivan's waking dream. Outside the Gestapo headquarters, documentary footage shows papers and trash littering a courtyard. A cut to the interior now shows Gal'tsev looking out on this space as soldiers sort through the remaining files and dossiers. But before we see his face, voices are heard over the soundtrack. In an interior monologue,

Gal'tsev asks if this is to be the last war in human history. Instead of providing an answer, Kholin's voice once again chastises Gal'tsev for his nerves, reminding him, now that the war is over, he should see a doctor about them. In fact, this is Gal'tsev himself assuming Kholin's voice; in a moment he recalls that Kholin has been killed on the way to Berlin. Once again to himself, Gal'tsev decides he needs to think further on his own survival.

It is through sheer chance in the moments following this brief interior dialogue that Gal'tsev learns the ultimate fate of Ivan. He approaches Vasil'ev, who sifts through files and reads off the methods by which the Gestapo has liquidated various Soviet prisoners. He glimpses the dossier on Ivan and, when it slips from the pile, jumps through a crater in the floor to retrieve it. Rising with the document in his hand, we see Gal'tsev's face, bearing fresh scars, for the first time in the Berlin scene. Ivan glowers back from a grim photograph, presumably taken shortly before his execution. Focusing on the picture, the object of Gal'tsev's gaze, Ovchinnikov's music becomes agitated and the camera begins to move through the ruined building. Still following Gal'tsev's line of sight, two German voices are heard over the soundtrack, an echo of the shouting throughout much of Ivan's waking dream. Here, however, the subject is much more specific. Though we are following Gal'tsev's gaze in a realistic setting, the voices suggest he is experiencing the final moments of Ivan's life, tracing the path the

boy took from his cell to the execution. Finally coming upon the gallows in the basement of the building, there is a cut to Gal'tsev as he looks into the room, then a dissolve from his face to a dirty guillotine. We are in the midst of another waking dream, but the addition of these documentary shots adds yet another dimension to the actuality of what is on screen, further blurring the line between dream and reality. And it is here that the two narrative planes ultimately converge. Unlike Ivan's reverie, where the conclusion is signalled by a return to reality, Gal'tsev's vision fully crosses over into the oneiric plane. The camera moves wildly about the room, coming to rest on Ivan's head rolling across the floor and then moving into a scene that bears the earmarks of the earlier dreams.

The final dream
The film's final sequence begins with a low-angle shot of Ivan's mother looking down on the boy as he drinks from the same bucket featured earlier. While the constructions match those of the first dream, the mother here does not die but simply waves farewell and walks away. Other images are also familiar from the earlier sequences, such as the dark-haired little girl and the river, but the presentation is slightly different. Johnson and Petrie, for instance, have noticed 'there is nothing particularly "dreamlike" about this particular scene' (1994: 75). None of the fantastic elements found in the early dreams are present; there is little if any spatiotemporal discontinuity or flying,

no negative images of a thunderstorm through the trees.

Music from the earlier dreams, however, is repeated on the soundtrack, continuing up until the final moments. Ivan and several other children play hide-and-seek on the beach in what looks like a continuation of the third dream. Gradually the others disappear and Ivan is left searching for the dark-haired girl. A blasted tree, similar to that at the ruined *izba*, stands incongruously in the background and flashes on the screen several times while Ivan finds and then chases the girl. As he overtakes her and runs out onto a sandbar, the music decelerates into a steady, ominous drumbeat. In the final shot, the camera, which has been following Ivan's run out into the water, suddenly moves back onto the beach and closes in on the tree. The drum continues and the tree rapidly darkens the entire frame, blocking out the sunlight just before the end credits appear.

3
Themes and Motifs

The mirror of *Ivan's Childhood*

That Ivan is a child divided between the grim reality of the war and the pastoral childhood of his dreams is a point no commentary of the film has failed to observe. Moving into the last dream sequence, however, there is clearly more at stake than simply describing a psychic split in the main character. How is one to make sense of this enigmatic final sequence, which retains many of the characteristics and imagery of the earlier dreams, but appears only after we learn that the dreamer himself has been murdered? Images of the previous scenes allude to memories of a lost innocence, and they are explicitly tied to the mind of the sleeping boy. In the final dream the direct links to Ivan seem to have disappeared, yet the images of the young girl and the boy himself on the beach form a continuation of the thread initiated in the dream before the final mission. Is it possible this is another flashback, not unlike the eerie sequence with Masha and Kholin in the birch forest, and that we have moved back in time to follow Ivan's consciousness in the final moments of his life? The emerging rhythm of the drum, conspicuously echoing a heartbeat, and its abrupt end following the dramatic shift from sunlight

to darkness conveys a vividly bleak finality to the film and suggests that the dream ends in his death. On the other hand, as the culmination of a deliberately evolving narrative approach, this is a passage of such importance that it is worth delving further into its profoundly ambiguous construction, and in particular its relations with the events which lead up to it. While there is undoubtedly enough room for multiple interpretations of this powerful scene, the tight exercise of narrative control described in the previous section makes it difficult to write this off as simply a moving lyrical coda tacked on by an overly enthusiastic young film-maker.

Perhaps the best place to start is to investigate how this sequence factors into a larger consideration of dreams in the film as a whole. To all appearances, these are endowed with more significance than simply a 'rhapsody of images' or the self-enclosed play of the unconscious mind. To borrow the words of the Russian theologian and mathematician Pavel Florensky (1882–1937), the dreams of *Ivan's Childhood* may very well function as an 'ontological mirror reflection of our world' (1996: 42). From the first sequence to the last, Tarkovsky's film emphasizes just such a reciprocal relationship between the worlds of dream and reality by consistently reflecting and inverting images, movements and sounds across these two narrative planes. This is not to say, however, that the dreams (and the last one in particular) necessarily represent a supramundane reality to be equated

with an afterlife. Rather, as in Florensky's theological description, the dreams are 'the boundary where the final determinations of earth meet the increasing densifications of heaven' (1996: 43). In Tarkovsky's work, however, we must bear in mind that this, as well as any other boundary, is not a hermetic seal but rather an interface or point of exchange. In several respects, we see a similarly porous liminality embodied and amplified in the physical obstacle of the river, which looms so ominously in the film as it divides the Russians from the Germans and, as underscored by the bodies of Liakhov and Moroz, the living from the dead. Like the dreams, the river is a line which at once separates and unites; the main action of the film involves the central characters crossing (and re-crossing) this polysemic frontier. Perhaps fortuitously, the image of the river brings with it the central physical motif of all Tarkovsky's cinema, water, which comes to function not only as a metaphor for the flow of time but, in several key sequences, adopts the reflective qualities of the mirror. Like the dreams, all of which prominently feature water, the mirror and other reflective or reflected images mark the horizon of the physical and the spiritual or, to anticipate for a moment, the actual and the virtual. It is within these liminal spaces, these frontiers and points of circulation, that seemingly discrete images, personalities and worlds converge and intertwine.

Before delving too deeply into the philosophical implications that arise from the chiasmic structure,

it is necessary to first take a closer look at the depictions of this dynamic interlacing and the various ways in which reflections and inversions resonate on different levels of the film. The previous section noted how the narrative may occasionally mingle the perceptions of different characters at critical moments of the film, a surprisingly mature demonstration of Tarkovsky's often fluid conception of individual identity. But destabilized subjectivity and shifting narrative attachments in individual shots and scenes are part of a larger system operating in the work's overarching structure. Spatial attachment gradually shifts from Ivan to Gal'tsev over the course of the story, and it is clear that framing the entire action between two dreams creates a kind of loose symmetry, enhanced by the repetition of certain images. But by the same token, the film also reverses itself via the recreation or correlation of images, delineating boundaries and then crossing them.

In the initial stages, this abundance of reflections and mirrored images describes a sharp distinction between the levels of dream and reality. In the opening shot of the film, for instance, Ivan stands behind a tree and looks out through a spider's web (Figure 3.1). A moment later the character moves out of the frame to the left just as the camera rises to the top of the birch. As it stops, Ivan reappears, moving back into the frame on the left but now at a considerable distance from his earlier position. The movement of this shot and even the cuckoo on the soundtrack is,

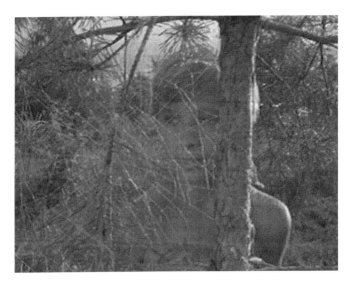

Figure 3.1: Ivan and the web.
Still from *Ivan's Childhood*.

incidentally, repeated almost exactly in the opening moments of Tarkovsky's *Solaris* nearly a decade later. The repetition in *Ivan's Childhood*, however, is far darker. Soon after waking from the dream, Ivan walks out of the crumbling windmill and the camera catches him moving out of the frame in the distance, again to the left. He quickly reappears in the immediate foreground, having completed in reverse the same elliptical motion of the dream. Moments later, as he moves through the swamp, there is another variation on this opening shot, in which the rising motion of the camera up the length of the tree is inverted. Now, as Ivan approaches through the stagnant water, the

101

camera descends along the blasted trunk of a dead tree. It is a harsh contrast to the live birch of the opening shot and an ominous foreshadowing of the dead tree which closes the film. The camera comes to rest as Ivan, still wading through the swamp, attempts to negotiate a line of barbed wire, a cold and unnatural alteration of the web seen earlier.

While this use of matched and inverted images continues throughout the film, the distinction drawn between the planes of dream and reality begins to blur as early as the second dream sequence. From a shot of Ivan's hand hanging over the side of Gal'tsev's cot, the camera scales up the wall to reveal the boy and his mother looking down from the top of a well. Within a moment, we see them staring at their reflections in the water and Ivan reaching through to break the surface, then magically appearing at the bottom and reaching through the water again as he attempts to grasp a star. Already in this early scene, there is an obfuscation of what is diegetically real and what is a dream. This is compounded by his physical movement at the mouth of the well, penetrating the reflective seam separating the two realms. The ambiguity and movement through different levels of reality becomes increasingly significant in light of the waking dream when the boy is alone in the church. It is in this climactic scene, where the fragile distinction of the real and the fantastic moves further into indiscernibility, that the film takes yet another dramatic structural and ontological turn. Here the reflective

qualities of the water coalesce into the mirror, which amplifies the boy's inward gaze but also serves to underline the split between the virtuality of the memories that invade his waking mind and his physical being in the present. Much like the reflection in the water, the image in the mirror marks the horizon between the mental and physical sides of his reality. But most importantly for Tarkovsky, it does so via the continual processes of time itself. As Gilles Deleuze describes the circuitry of the reflection, focusing on the bifurcation of the present moment, 'the present is the actual image, and *its* contemporaneous past is the virtual image, the image in a mirror' (Deleuze 1989: 79, original emphasis). The relevance of this coexistent virtual past and the transcendent threads of time will become clear shortly, but here it is important to note that this mirror image appears in the midst of a highly ambivalent narrative perspective. The camera has assumed Ivan's gaze, but does so at a moment when he is looking into himself, experiencing his seemingly actual presence before the mirror and the virtual reflection within it. While this apparent split, localized at the intervallic instant between the present and the past highlighted by the mirror, may indeed imply the disintegration of the character's psyche (the boy we *see* before the mirror is not looking into it) it may also, paradoxically, open the door to a greater, more stable reality than the illusion of static individuality. Ultimately, discrete notions of identity give way to suggestions of a larger consciousness,

ostensibly dispersive in the real world of the war but edging towards a kind of unified multiplicity within (and occasionally outside) the virtual world of the dreams. This is hardly an unusual event in Tarkovsky's work. Though there are occasionally thinly developed stereotypes in these films (most often these are women), central characters are rarely fixed individual beings and often develop through a kind of integrated mediation, a profound personal identification or correspondence with others. Such is the case with Rublev and Boriska in *Andrei Rublev*, Domenico and Andrei Gorchakov in *Nostalghia* and, in a less obvious manner, Ivan and Gal'tsev.

The subdued connections between the two rise to the surface with the conclusion of Ivan's waking dream. Gal'tsev rushes into the church as the barrage continues to thunder outside and attempts to reassure Ivan. He comes to a stop in the foreground of the frame just before the boy's reflection again steps into the same mirror (Figure 3.2). Ivan assures him he is not afraid and the film returns to the explosions outside before settling on the shot of the cross slowly coming into the sunlight. Back in the church, the positions of the two characters are now reversed; it is Gal'tsev's reflection in the mirror with Ivan now in the foreground (Figure 3.3). Gal'tsev has moved into the virtual space previously occupied by the boy, and it is from here that we may begin to realize more clearly a continuum of similar images, a transitioning of one in the place of the other through physical and mental spaces. Ironically, this scene also marks one of

Figure 3.2: Gal'tsev and Ivan at the mirror.
Still from *Ivan's Childhood*.

their most bitter confrontations, as Gal'tsev attempts to endorse Griaznov's decision to send Ivan to a military school. But this is also the last time the two characters will be at odds; just beneath their argument, the foundation has already been prepared to draw them closer together.

To be sure, the links between the two do not begin with this scene before the mirror, though it is a central moment in the process. The mirror itself, it is worth repeating, is not merely a physical device within the diegesis, but an overriding structural principle of Tarkovsky's narrative. We have already seen how attachment to the characters shifts over the course of the

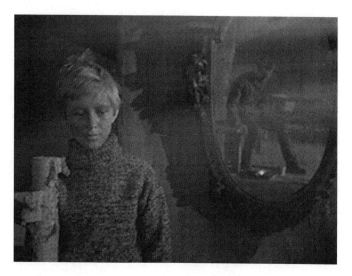

Figure 3.3: Ivan and Gal'tsev at the mirror.
Still from *Ivan's Childhood*.

film from Ivan to Gal'tsev, concluding with a complete
attachment to him by the time of the film's epilogue
and final dream – a reversal of the attachment to Ivan
in the pre-credit sequences and opening dream. If we
consider this in light of the link between Ivan and
Gal'tsev forged in the shots after the bombardment,
its possible antecedents and the direction this asso-
ciation will soon take, it becomes increasingly clear
just how fully these reflections and correlated images
permeate nearly every aspect of the film, elegantly
integrating the underlying ontological orientation
with its overall structure. From the opening scenes of

106

Ivan's Childhood, Tarkovsky uses a series of graphic matches to actively encourage the viewer to link the characters of Ivan and Gal'tsev, working counter to their obvious differences and confrontations as the story begins. The matches, shots consisting of similar compositional patterns and elements repeated over the course of the film, reinforce a largely unseen connection between the two and, most importantly, set the stage for the film's enigmatic finale. But what is particularly intriguing, especially for the comparatively inexperienced film-maker, is that the matches are coordinated with the shift in spatial attachment. Shots early in the film are usually echoed after considerable portions of time have elapsed. But as narrative gravity shifts to Gal'tsev, these visual rhymes increasingly occur in almost immediate succession.

As we saw in the precredit sequence, Ivan is framed by a web and moments later a similar shot has him sneaking behind barbed wire. Jumping ahead to the epilogue, there is a faint echo of this in Gal'tsev, now in the ruins of Berlin, with fresh scars intersecting his face and framed by a strand of barbed wire in the moments before he experiences his own variation of the waking dream. A more precise match between the two is initiated soon after the credits when Gal'tsev rises to begin his initial interrogation of Ivan. As he sits on the bed, the message from the murdered Soviet prisoners, which will figure more prominently in the waking dream, is visible on the wall behind him (Figure 3.4). When Gal'tsev rises, the camera

Figure 3.4: Gal'tsev at the wall.
Still from *Ivan's Childhood*.

pauses for a moment on the message. Much later, as the characters sit in silence before Ivan's final departure across the river, the boy sits before the message in a precise reversal of Gal'tsev's position (Figure 3.5). Once again, as he rises and moves out of the frame, the camera continues to linger on the words. While these rhymes take place more or less at the fringes of the film, many more significant ones occur near the centre, circulating around the zone of narrative transition. In addition to the matches with the mirror just discussed, there is another key sequence a short time earlier as the characters look over the captured Dürer album. As already mentioned, this is an instance in which the film seems to be mingling the perspectives

Figure 3.5: Ivan at the wall.
Still from *Ivan's Childhood*.

of both characters, a subtle hint that Gal'tsev is at least partially looking at the world through the eyes of the boy. This is a theme that recurs throughout Tarkovsky's career, perhaps most explicitly in his next film, *Andrei Rublev*, where the title character actually confesses to his colleague Daniil that he sees the world through his eyes. In *Ivan's Childhood*, the united gaze of the two characters is underscored by a match of their faces between the subjective shots. Both are shown with the bottom halves of their faces covered by the album (Figures 3.6 and 3.7) and their eyes isolated within the frame. Interestingly for a Soviet film-maker (who, unlike most of his countrymen, *did* have wide access to western films), the sequence seems

Figure 3.6: Ivan looking at the album.
Still from *Ivan's Childhood.*

Figure 3.7: Gal'tsev looking at the album.
Still from *Ivan's Childhood.*

to take its cue from the scene on the train in Alfred Hitchcock's *39 Steps* (1935), where Hannay realizes he is being pursued for the murder of Miss Smith.

Many of the more important visual rhymes in the film relate this fixation on the gaze with identical movements. This is particularly evident in the moments before Ivan's third dream. Interestingly, his sister, if this is indeed the girl in the dream, appears only after Gal'tsev has been made aware of her in the conversation with Kholin – and it is difficult not to notice the strong resemblance the girl bears to Masha. Though Gal'tsev is clearly quite taken with the young medical officer, she is also the one significant character in the film with whom Ivan has absolutely no contact – the sensitive nature of his work demands that his presence in Gal'tsev's camp be kept secret from all but a few soldiers and officers. It is worth recalling that in Bogomolov's novella Ivan's lost sister is an infant and only briefly described. We may still speculate that this is just how Ivan's sister may have looked but the illogical possibility that Gal'tsev somehow plays a role or is somehow associated with the composition of the dream becomes more plausible in light of what occurs in the moments before Ivan falls asleep.

At their dinner, Kholin has just announced that Katasonych will not be going on the mission (we learn shortly that he has been killed) and Gal'tsev will be taking his place. As Ivan leaves the table to lie down, Kholin launches into his admonishment of the young officer. The camera executes a whip pan, catching Gal'tsev just as he folds his hands behind his head

and answers with the rhetorical, 'What am I, a child' (Figure 3.8). This is followed by a cut to Ivan making exactly the same motion on the bed (Figure 3.9). As in all the pre-dream sequences, the perspective shifts to that of the boy as his eyes scan the ceiling above him and come to rest on the message scrawled on the wall. The shot is at an impossible angle from his position on the bed (and vividly characteristic of Tarkovsky's mature distortions of spatiotemporal relationships in the later films), but would easily fall within Gal'tsev's field of vision from the table. Again, the gaze of the two characters is intertwined, suggesting a tentative fusion of perspective and, with more subtlety, even consciousness as it lays the ground for the most perplexing scene of the film.

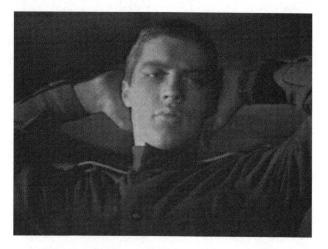

Figure 3.8: Gal'tsev at the table.
Still from *Ivan's Childhood*.

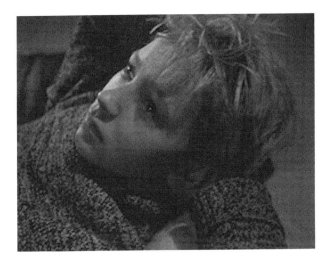

Figure 3.9: Ivan in the cot.
Still from *Ivan's Childhood*.

Gal'tsev's experience in Berlin expands this already vast network of mirrored images. The moments before the final dream sequence echo Ivan's waking dream earlier in the film where, once again, the shift into his perspective is announced not with a direct POV shot, but the verbalized expression of his thoughts. As the camera assumes Gal'tsev's perspective in the diegetic present, the voice of the executioner dragging the boy from his cell emerges from the past. This discontinuity between the film's dual informational tracks, however, is not a complete split; the spatial arrangements and movements through the building conform to what the voices are saying. It is essentially a temporal disjunction that causes us to hear the past but see

the present in the ruins of the building in which the murder was carried out. The transition to the dream sequence attempts to bridge this final gap. Reliving the last moments of the boy's life as he looks into the execution chamber, Gal'tsev moves more deeply into the child's perspective, and the camera appears to fall in synch with his gaze as it spins about the room, finally looking into, and then through, Ivan's eyes the moment the final sequence begins.

Admittedly, this last contention is a logical impossibility. But illogical movements and perspectives are already well established by this stage of the film. The first shot of the final dream repeats, almost exactly, the last shot of the first: smiling at her son, Ivan's mother wipes her head with the back of her hand (Figure 3.10). In the next shot, Ivan raises his head from the bucket and, as in the first dream, makes the same motion (Figure 3.11). The explicit link to the first dream, and thus Ivan's consciousness, is unmistakable. But this movement offers yet another direct implication of Gal'tsev. In his final appearance on screen, immediately preceding the shot of the guillotine, Gal'tsev makes precisely the same motion with his right hand as he stares into the room (Figure 3.12). Tellingly, it is also Gal'tsev's right hand that introduces him into the film and forms, perhaps, the initial connection with Ivan. The first shot after the opening credits has his hand suspended over the bed in the darkness, an image reflected as Ivan's hand hangs over the bed in the first moments of the second dream (Figure 3.13).

Figure 3.10: Ivan's mother: final dream.
Still from *Ivan's Childhood.*

Figure 3.11: Ivan: final dream.
Still from *Ivan's Childhood.*

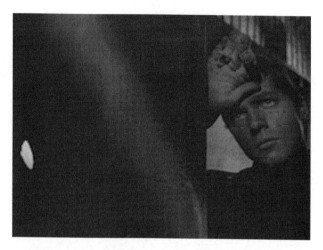

Figure 3.12: Gal'tsev in Berlin.
Still from *Ivan's Childhood*.

Figure 3.13: Ivan: second dream.
Still from *Ivan's Childhood*.

From this could follow several explanations for what we see in the film's final sequence, though by this point it is clear we have moved beyond considering the dreams as 'realistic' in the sense that they directly depict the function of the unconscious mind. This is not a dream experienced, in the conventional sense, by more than one person. Rather, as the filmmaker described the final moments of his film *Nostalghia* (1983), in which we are again presented with an oneiric scene that takes place after the dreamer appears to have died, the dreams of *Ivan's Childhood* contain at least, to perhaps overstate the obvious, 'an element of metaphor' (Tarkovsky 1986: 213). But however tempting it may be to try and decode the images or symbols into a coherent and stable explanation, it is important not to obscure the fact that this is, at its core, the restrained expression of a larger unity created by means of the associative linking we have seen throughout. Indeed, what is being expressed largely exceeds the capabilities of visual or literal description. And yet this metaphor, due specifically to its extra-verbal nature, contains a profoundly direct statement on the deeper nature of time and memory.

As Tarkovsky himself later remarked, the dreams of this film were based on his own childhood recollections (1986: 30). Transposed onto Ivan, they become pieces of the past piercing through his present perception. While each contains elements of the uncanny triggered by the imagination, they are not

117

lyrical abstractions intended only to facilitate the emotional involvement of the viewer, nor are they the repetition of previous events – his mother was not killed in two different ways. Still, the repeated movements and positionings outlined above emphasize a distinct circuit with diegetic reality. And it is here, perhaps, that the ideas of the philosopher Henri Bergson become increasingly relevant. As he wrote in a short essay on dreams, 'the power which gives form to the materials furnished to the dream by the different senses, the power which converts into precise, definite objects received by the eyes [...] is memory' (Bergson 1920: 115). Not surprisingly, the oneiric sequences of *Ivan's Childhood* have often been interpreted as moments of the boy's life before the war.

While in a more limited sense this is indeed the case, there is also more at work than the unconscious play of the boy's personal memories or individual recollections. The parallels between Tarkovsky and Bergson become particularly illuminating when we consider the nature of recollection itself. In *Matter and Memory* Bergson declares that 'there is no perception that is not full of memories' (1991: 24). Even if our perception in the present is our actual physical being in the material world, it is forever imbued with whispers of the past. Memory, in this reading, 'imports the past into the present, contracts into a single intuition many moments of duration' (Bergson 1991: 80). In consciousness, there is a continual interpenetration of the present and the past, the

actuality of perception and the virtuality of memory. There are, essentially, two sides to our lives:

> Our actual existence, then, whilst it is unrolled in time, duplicates itself all along with a virtual existence, a mirror image. Every moment of our life presents two aspects, it is actual and virtual, perception on the one side and memory on the other.
>
> (Bergson 1920: 165)

The similarity of this statement to the earlier quote from Deleuze is not a coincidence; it is largely Bergson's ideas (with no small contribution from Tarkovsky's theoretical writings) that provide the framework for his concept of the time-image in cinema. For both the philosophers and the film-maker, memory is explicitly 'a spiritual manifestation' (Bergson 1991: 320). Though Tarkovsky does see this from a decidedly more theological perspective, he was almost certainly channelling Bergson when he wrote in *Sculpting in Time* that 'Memory is a spiritual concept!' (Tarkovsky 1986: 57). Perhaps most interesting in this respect, the being of memory resides not in the physical brain but in the virtuality of time: the past has its own ontological character as an aspect of duration, the coalescence of different times conceived not as chronological succession but an organic whole of past and present in which the discrete moments we seem to experience permeate into one another. As Deleuze later attempted to clarify, duration is coextensive with an 'immemorial or ontological Memory', which is not

119

preserved in the brain or any other physical space, but in duration, or time, itself (1991: 57). Bergson states, 'there cannot be in the brain a region in which memories congeal and accumulate. The alleged destruction of memories by an injury to the brain is but a break in the continuous progress by which they actualize themselves' (Bergson 1991: 160). More simply, for Bergson – and seemingly Tarkovsky as well – memory possesses a life of its own, one that continually develops and expands independently of the remembering consciousness as part of the past, 'a power absolutely independent of matter' (Bergson 1991: 81).

With the passing of the present, the past does not cease to exist but continues outside of the perceiving organism. This instantaneous split and distinction between actual and virtual will be crucial to Tarkovsky's presentation of time, but suffice it here to note that it is the coalescence of a preserved past and the present, the interlacing of memory and perception, which fuels the waking dream of Ivan as well as Gal'tsev's reverie in Berlin. Both characters experience their actual present shot through with visual and aural images of the past. The problem, of course, is that this is not restricted to Gal'tsev's own experience. But it is precisely the apparent impossibility of both his vision in Berlin and the final sequence that speaks to the dreams as the points from which the more profound depths of time and memory emerge. This intersection of the virtual and the actual forms a point where subjectivity, as it is usually conceived, drops away. And it is here that the dreams

take on a definitive note of transcendence and mark an aesthetic movement into the invisible realm of our existence. To return to Florensky's terminology, 'the dream happens whenever we cross from one shore to the other' (1996: 43). In Tarkovsky's work, transcendence, this crossing over outside of the self, is often (if not exclusively) dependent on the implication of the other. It is corollary to this that there are so many paired characters in his work and so many idiosyncratic traits shared by individual figures. The immersion within or assumption of the subjectivity of another (metaphoric though it may be) ultimately underscores the fragile contingency of identity and the unfinished nature of individuality. But its ultimate goal is to communicate the experience of a larger whole, the intimation of something conventionally indescribable. Such is the case with Gal'tsev, whose experiences in Berlin are cast as the movement into a different kind of subjectivity, one which recalls an important expression from the poet Vyacheslav Ivanov's exegesis of Dostoevskii, *proniknovenie* or penetration:

> It is a transcension of the subject and object. In this state of mind we recognize the other Ego not as our object, but as another subject. It is therefore not a mere peripheral extension of the bounds of individual consciousness, but a complete inversion of its normal system of coordinates.
>
> (1959: 26)

Aside from the medium – and in large part owing to it – what is different in Tarkovsky's work is the extent

to which the emphasis on memory and its virtual being in time shape this immersion into the world of the other and the inversion of everyday logic. Indeed, this 'immemorial or ontological Memory' seems to emerge as perhaps the strongest thread connecting Gal'tsev with Ivan. While on a certain level it is correct to take the dreams, and the final one in particular, as metaphor, the deeper nature of time, the engine for this movement outside of the self, emerges through them in a decidedly more direct manner.

The reflection of time

Tarkovsky is often described as a 'poetic' film-maker, a term which, as much as anything else, reflects the obscurity and complexity so many viewers find in his work. Still, as a 'poetic' film, the deceptively intricate stylistics of *Ivan's Childhood* detailed above provide ample justification for the term, as does its place at the vanguard of the Soviet poetic cinema movement of the 1960s and 1970s. While Tarkovsky was characteristically unstinting in his disparagement of many of the films that followed in his wake, the idea of 'poetic cinema' is not something he outright rejected – quite the opposite. In his later writings on cinema, the word poetry appears more or less synonymous for lofty spiritual or religious art of any medium. In no uncertain terms, Tarkovsky declares art to be a kind of spiritual practice which functions, in a phrase that makes it sound very much like a science, as 'a means of assimilating the world, an instrument for

knowing it in the course of man's journey towards what is called "absolute truth"' (1986: 37).

For someone who seemed to have few qualms with being labelled a Soviet artist even well after the time *Ivan's Childhood* was made, the sharp incongruity of such statements within the historical context may have diminished over time, but the unambiguously spiritual overtones of Tarkovsky's work remain unusual for Russian and, especially, Soviet cinema. Understandably for many, the religious tenor of the works comes across as pretentious or deliberately vague; these are not films made to suit every taste. Moreover, none of them explicitly embrace an Orthodox point of view any more than they do a specifically Soviet one. Though traditional Christian imagery abounds in *Ivan's Childhood*, it operates within a framework more dynamic and complex than simply its (for the time) ambitious display, or even the intensely moral perspective described so well in Jean-Paul Sartre's commentary. One cannot call this a 'religious' film within the more narrowly determined confines of any specific faith or denomination, but *Ivan's Childhood*, like all of Tarkovsky's mature works, unquestionably incorporates elements of what Paul Schrader (2018) described as 'transcendental style' in cinema. Fleshing this out into something more concrete, however, is no simple task, even when using the categories Schrader provides. There is more at stake in this work than creating scenes or sensations of disparity and stasis, the characteristics

123

of transcendental cinema he outlined in the original 1972 study of Robert Bresson, Carl Theodor Dreyer and Yasujiro Ozu. Schrader himself, in fact, later considered these categories to be insufficient and in his more recent reworking of the book isolated the changes in the medium and the reasons why, he felt, a re-evaluation of his concept was necessary: 'What happened? Gilles Deleuze happened. So did Andrei Tarkovsky' (Schrader 2018: 1). In some respects, this association may seem incongruous and, indeed, it is important not to push the parallels between the two too far, especially if the focus is on spirituality and transcendence. And yet the concept of time and, as we have seen, memory is a remarkable area of convergence. For both, time emerges as the most important and distinctive aspect of modern cinema. The 'discovery' of cinema's ability to create a pure expression of time outside normal human perception obviously predates both Tarkovsky and Deleuze, but they do seem to be among the first to give it a coherent voice. As Schrader points out, both 'were simultaneously working on the same paradigm shift' (2018: 6). Still, there remain a number of problems when comparing the two. Tarkovsky does not seem to have been aware of Deleuze's earlier works and *Cinema 2: The Time-Image*, in which the temporal dimensions of cinema are exhaustively detailed and explicit references to the Russian director are made, was only published in 1985, the year before Tarkovsky died. For all of the respect Deleuze shows to Tarkovsky's ideas in

the book, his readings of the films themselves seem to be lacking. As Anna Powell has written, Deleuze has an 'overwhelmingly pessimistic slant' on the crystalline properties of Tarkovsky's time-image (Powell 2007: 156). And so, though the two hit many of the same marks in the ontological treatment of time and the technical means of its expression, they appear to take the discovery in slightly different directions or perhaps have different ideas of what it may represent. As the portal to the larger spiritual and philosophical themes of Tarkovsky's later career, the penetrating exploration of time and memory is clearly at an early stage of development in *Ivan's Childhood*. But it is central nonetheless and it is in this arena, beyond the recognition of Deleuze, that the work finds purchase in some of the most profound areas of twentieth-century philosophical thought. Without going too far afield, however, a brief consideration of the intersection of cinema and philosophy in Tarkovsky's work is in order.

In Russia, over the last few decades, a number of studies have been unequivocal in their evaluation of the director as a philosopher and not simply an idiosyncratic auteur. Dmitrii Salynskii's 2009 book on cinematic hermeneutics, for example, makes the point explicitly on its very first page: 'Andrei Tarkovsky was not just a director, but also a philosopher' (Salynskii 2009: 5). Much as Tarkovsky's work engages with some of the more stimulating areas of philosophical inquiry, however, the label is problematic for a number of

reasons – not the least of which are statements from the film-maker himself. In his theoretical works, Tarkovsky articulates some of the complex ideas at play in his films with a lucidity few film-makers could command in their prose, but he quite clearly lacks any formal philosophical training; at no point does he even make the pretence of engaging in a systematic philosophical enterprise. Moreover, the explicitly metaphysical tone of his writing is more germane to the Russian religious philosophers and theologians of the first half of the twentieth century than European thought of the second. Perhaps Schrader provides the most accurate assessment when he writes, quite simply, that 'Tarkovsky was an aesthetician as well as a filmmaker' (Schrader 2018: 7). The director himself was rarely shy about expressing his (often negative) opinions on the work of others and his strong convictions on the spiritual necessity and prophetic mission of art; in later writings and interviews, he is strident in his characterizations of the poet as engaged in a sublime, visionary discipline. As philosophy these statements often sound awkward and imprecise, but, when tempered with an appropriate amount of caution, may be extremely valuable in approaching the films. In addition to the direct references Tarkovsky makes to the divine mission of Aleksandr Pushkin's 'Prophet' (1827), there are also clear affinities to a number of more recent European thinkers. The most conspicuous of these is perhaps Paul Valéry, the French poet and essayist whom Tarkovsky cites repeatedly in *Sculpting in Time* and whose own complex association

with philosophy seems to have had a decisive influence on the film-maker's writings. As often with Valéry, for Tarkovsky philosophy and art are intimately related, though not necessarily coincidental:

> Philosophy seeks the truth, defining the meaning of human activity, the limits of human reason, the meaning of existence [...] The allotted function of art is not, as is often assumed, to put across ideas, to propagate thoughts, to serve as example. The aim of art is to prepare a person for death.
>
> <div align="right">(Tarkovsky 1986: 43)</div>

Art, as he puts it, 'flies in the face of philosophical concepts. The poet does not use 'descriptions' of the world; he himself has a hand in its creation' (Tarkovsky 1986: 41–42). This last phrase, in which the artist participates in the creation of reality, is particularly charged. In an essay Tarkovsky almost certainly did not know, Maurice Merleau-Ponty offers a strikingly similar description of the divergence between the philosopher and the artist: 'the philosopher looks to express the world, the artist seeks to create it' (2003: 46). Of course, the ideas are not unique to these two thinkers, but even more interesting is the fact that, in this essay, Merleau-Ponty situates time within the context of Bergsonian duration as the means through which the Absolute becomes accessible through finite reality, enabling a mode of perception which confronts the diversity of the material world in an attempt to create a sensation of the unity

that underlies it. Time qua duration is not merely the aperture through which the infinite becomes discernible, it operates on a continuum linking the unity of the Absolute with individuated reality:

> we are no longer in a philosophy of Being, which can distinguish the Absolute from the finite, but rather we are in a philosophy of time [...] This recourse to temporality is another way of explaining that there is no separated Absolute.

(Merleau-Ponty 2003: 48)

It is worth noting the paradox, which pertains to Tarkovsky as well, that it is through time that the 'groundlessness, eternality, independence from time', which Friedrich Wilhelm Joseph Schelling uses to describe the Absolute, is revealed (2006: 21). Though Merleau-Ponty tends to regard Bergson with a healthy dose of scepticism, the link he describes to Schelling is convincing, as is his assessment (again, in this same essay) of the ability of art to communicate a sensation of unconditional reality. The similarity to Tarkovsky's descriptions of the transcendent potential of art is unmistakable: 'Through the image is sustained an awareness of the infinite: the eternal within the finite, the limitless given form' (Tarkovsky 1986: 37). In both cases, time acts as a kind of conduit through which a sense of the invisible is conveyed and it is here that we begin to approach the deeper layers of Tarkovsky's work and the larger significance of his experiments with time in cinema.

Depending on the reader, the somewhat ambiguous metaphysics and numerous allusions to the

infinite in Tarkovsky's theoretical writings may be provocative or confusing in the context of his creative work, but their ambiguity takes on a much more coherent shape when cast against a larger philosophical background. It remains difficult to determine how deeply the intellectual roots connect, but there is clearly an affinity with idealistic philosophy and German Romantic thought in particular. Repeated references in *Sculpting in Time* to intuition as a means of grasping a larger reality suggest there is more than a passing acquaintance. But the importance of intuition in Tarkovsky's aesthetic also reveals more of the profound coincidence with the thought of Henri Bergson. In Bergson's work, the Absolute becomes discernible primarily through intuition, through an overturning of the habitual, analytical workings of the intellect and an immersion within the perpetually unfolding movement of duration. Incidentally, this connection to Bergson is also very much in line with Tarkovsky's surprisingly negative reaction to the idea of symbolism in his work. This is not to say that there are no symbols in the films – there clearly are – but it is the thing in itself which is of primary importance, rather than any concept it may represent. It is the physical object or image itself which opens directly onto the infinite. Between what we are shown and the Absolute, there is no gap to be conceptually traversed through the use of a symbol. In somewhat similar regard, time, in an immediate sense, becomes a central component in communicating a sense of

transcendence, the identity of subject and object and the continuity of the material and the spiritual. The artistic expression acts as a kind of catalyst to intuition, which here is an intuition of duration and the infinite multiplicity of durations contained within it, not merely that of one's own consciousness.

Vague and esoteric as this may be in the above description and Bergson's writing, the context of the films creates, or modifies, a reality more distinct and comprehensible - albeit still not fully explicable through our usual discursive means. Time, even in as early a film as *Ivan's Childhood*, stands at the threshold of the absolute. The cinematic reconfiguration of time attempts, in the first place, to make perceptible processes that occur largely outside of our normal perception. This, in turn, demands a corresponding aesthetic form, one in which logical spatiotemporal coordinates are displaced and the traditional subjective/objective distinction is loosened. As the philosopher Keith Ansell Pearson explains,

> Time is invisible and is rendered visible only when the interests of effective action are suspended or relaxed, for example, in unique circumstances such as states of dreams or through special non-utilitarian praxis (forms of art such as painting and cinema, for example).
>
> (2002: 159)

Ivan's Childhood, like all of Tarkovsky's mature films, is made so distinctive - and difficult - by the fact that the narrative method itself enacts the ontological

orientation which motivates its creation. The film fashions a world (and a perception of the world) which attempts to engender in the viewer an intuitive and direct experience of the non-conceptual reality underlying our everyday understanding, outside and quite different from a discursive explanation.

This returns us to Deleuze's concept of the time-image in cinema and its relationship to Tarkovsky's work. As Slavoj Žižek has written, 'perhaps Tarkovsky's films are the clearest example of what Deleuze called the time-image replacing the movement-image', and few serious discussions of his work can fail to note the relationship (2007: 102). What is often missed, however, is the extent to which not only the films, but Tarkovsky's ideas on cinema and time appear to have influenced the creation of this concept. Deleuze quoted Tarkovsky in interviews and at length in the English introduction to *Cinema 2: The Time-Image*. The impact of Tarkovsky's 1979 article, 'On the cinematic image' ('O kinoobraze'), which appeared in French translation in 1981 and was later incorporated into *Sculpting in Time* (Tarkovsky 1986: 104–63) is unmistakable in Deleuze's writing. And again, for both the philosopher and the film-maker it is clear that time, '*imprinted in its actual forms and manifestations*', stands as the great and largely unacknowledged achievement of cinema (Tarkovsky 1986: 63, original emphasis). To describe *Ivan's Childhood* or any other Tarkovsky work as a 'time-image' film, however, does little to further our overall understanding. Schrader's

argument, that in Tarkovsky's films 'time was not a means to a goal. It was the goal' is convincing (2018: 8). But at the same time, this goal involves more than moving beyond time as it is habitually conceived.

It is worth pausing here for a moment to look briefly at how the film manipulates time at its more basic level. Despite the complex terminology and categorizations, Deleuze's taxonomy of the time-image is not entirely rigid; there seem to be as many types as there are individual film-makers or films. For Tarkovsky, too, the 'sculpting' of time varies from film to film, with a particular emphasis on the ponderous gravity of duration as it emerges in the extended, eerily slow tracking shots of his mid- and late-career films. We undoubtedly see a trace of these future tendencies in the uncomfortably long shot of the cross emerging from the smoke of the German bombardment but, for the most part, *Ivan's Childhood* lacks the extreme long takes, which so effectively bring to the fore the pressure of time and which, when encompassing the impossible movements of characters and objects within single shots, create extraordinary sensations of time as a force eclipsing movement and warping the perception of space. But what happens in this film is not altogether unrelated and even shots of significantly shorter length inevitably draw our attention, however subtly, to the flow and movement of time.

To cite just a few of the more unassuming instances, it may be easy to overlook how quickly Ivan, in the

film's first shot, moves from his place by the tree and then, following a brief interval off screen, steps into the background. The movement is rapid, but not overly so. However, when this motion is reversed a few moments later the spatiotemporal distortion is unmistakable. From a small figure in the background walking from the windmill Ivan suddenly moves into the foreground of the frame in a medium close-up, having covered the distance off screen as if he were sprinting. This contraction of time is already characteristic of Tarkovsky's mature works, where characters frequently disappear off screen only to reappear seconds later in positions contra-logical to the moments that have passed. But while these instances of illogical movement are interesting in and of themselves and stimulate in the viewer a sensation of time being altered, they assume a much more significant character when paired with the film's persistent manipulation of perspective.

Time, as it is presented in Deleuze's description, is the flow and movement of duration, the permeation of heterogeneous moments into a qualitative multiplicity, which preserves the past within a perpetually moving, everlasting present, rather than sequential chronology subordinated to movement. But this non-spatialized, nonchronological account of time is also intricately linked to (if not determined by) consciousness and subjectivity. Interestingly, soon after the premiere of *Ivan's Childhood* Tarkovsky was already attempting to articulate his work along similar

lines: 'I am seeking a principle of montage that will allow me to expose the subjective logic – the thought, the dream, the memory – instead of the logic of the subject' (Gianvito 2006: 11). In this capacity, it is the shot that often functions as the expression of subjectivity and, consequently, the corresponding intuition of duration in consciousness. Though we habitually think of both moments in time and conscious states within time as individuated they are, in the underlying duration from which they spring, aspects of a unified heterogeneity (Bergson uses the example of a flock of sheep), in which what we habitually consider to be discrete moments and phases actually flow into one another in constant motion – a 'multiplicity without divisibility', as Bergson writes (1956: 44). This is both individual and universal experience, time as a flow or passage corresponding with the inner life of consciousness. However, within this virtual multiplicity, the individuated consciousness also interpenetrates other durations. Other aspects or consciousnesses are enfolded within what Deleuze later tries to clarify as the 'single, universal and impersonal Time' (1991: 80). Thus, 'my duration essentially has the power to disclose other durations, to encompass others and to encompass itself ad infinitum' (Deleuze 1991: 80). Bergson puts this a little more simply: 'perception appears rightly or wrongly to be inside and outside us at one and the same time [...] a surface film of matter in which perceiver and perceived coincide' (1956: 45). With the presentation of both time

134

and subjectivity in *Ivan's Childhood*, Tarkovsky strikes into a remarkably similar vein. The mingled perspectives that appear with such frequency in the film correspond quite well with this coincidence between the perceiver and perceived and, with this, the interpenetration of individual durations. It is worth pointing out again that a number of these instances where the narrative merges the perception of Ivan and Gal'tsev, such as the moments before the dream of the apple truck and Gal'tsev's disturbing vision in Berlin, also involve a noticeable disruption of logically continuous spatiotemporal coordinates or audio/visual disjunctions.

Perhaps more explicitly than any of the later films (with the obvious exception of *Mirror*), the temporal dynamics of *Ivan's Childhood* are synchronized with an exploration of subjectivity and consciousness. The diegetic present, particularly when filtered through the perception of these characters, is often saturated with pieces of the past, occasionally to the point where the line between present and past or fantasy and reality becomes indiscernible. As Deleuze would explain, 'subjectivity, then, takes on a new sense, which is no longer motor or material, but temporal and spiritual: that which is added to matter, not what distends it' (1989: 47). This would appear to be rendered most efficiently in Ivan's waking dream, where fantasy and memory so fully overtake the boy's perception of the present, that the distinct layers of time and reality become nearly indistinguishable. But

the boldest crescendo in the play with perception is the final sequence with Gal'tsev, where the invasion of the past into the present effectively erases the distinction of individual experience. As Gal'tsev moves through the ruins of Berlin, the disjunction between the audio and video tracks creates an ambiguous situation which magnifies the simultaneous experience of present and past in normal perception to create an extreme, seemingly illusory situation. And it is precisely when this tension between the present and what Deleuze would call 'sheets of the past' rises to such levels that the thin perimeter between perception and memory, the experience of the present and the past, begins to fade. In fact, this focus on what is real in the physical sense and the point at which it passes into the altered, immaterial reality of memory is arguably central to Tarkovsky's metaphysical program and, to varying degrees, informs all of his mature cinema. To borrow André Bazin's description of neo-realism, this approach to temporality and the concentration on the horizon between the physical and the spiritual is clearly 'more an ontological position than an aesthetic one' (2005: 66). But as in so many cases where philosophy and art successfully intersect, the consequences of the former tend to determine the character of the latter.

Here, once again, it is the figure of the mirror, the physical and symbolic locus of the horizon at which the dynamic process of time takes place, which conspicuously lays bare what the work attempts to

express, where it reveals time's 'differentiation into two flows, that of the presents which pass and that of the pasts which are preserved' (Deleuze 1989: 98). It is within this narrow channel, the interstice in which the present falls into the past and where perception fades into memory that an image of time most explicitly materializes in *Ivan's Childhood*. The mirror tightens the circuitry of the virtual and the actual to the degree that there emerges what Deleuze calls a contracted, double-sided image, the effect of which is to make palpable the instantaneous, yet boundless dimensions of the present as it enters our perception. The time-image in cinema serves to heighten the perception of what happens in the everyday, where the infinity of duration becomes accessible through the present moment.

But while for Deleuze, the description of the reciprocal nature of the actual and the virtual is often the end in itself, Tarkovsky pushes it further into a more explicitly spiritual, even mystical direction, and in the process creates an especially deep penetration into the nature of human experience. In the time-image, the inconceivably vast, unified multiplicity of duration becomes accessible through an immeasurably brief, seemingly individuated actual present. In parallel fashion, and distinctive to the Tarkovskian time-image, the film-maker attempts to create a kind of aperture into the Absolute through a seemingly paradoxical concentration on the physical world. To reiterate the earlier quote from *Sculpting in Time*, the

works attempt to express 'the eternal within the finite, the spiritual within matter, the limitless given form' (Tarkovsky 1986: 37). It is little wonder then, given the explicit use of the physical as a means for rendering sensible that which remains hidden or unseen, that a thinker of Žižek's acuity would find Tarkovsky's work determined by the 'notion of a heavy, damp matter (earth) which, far from functioning as the opposite of spirituality, serves as its very medium' (Žižek 2007: 249). And clearly, the persistent attention devoted to water, mud and the worn faces of the soldiers, demonstrates that the apposite description of 'cinematic materialism', where 'we enter the spiritual dimension only via intense direct physical contact with the damp heaviness of the earth' pertains just as well to *Ivan's Childhood* as it does to the later films in Žižek's commentary (2007: 248, 249). To push this slightly further, much of Tarkovsky's work, and this film, in particular, seems to be working along lines similar to that of the mystical philosopher Vladimir Soloviev. The cinematic materialism noted by Žižek often seems to be geared towards creating the sensation of 'a complete mutual permeation and liberated solidarity of the spiritual and the material, the ideal and the real, the subjective and the objective factors and elements of the universe' (Soloviev 2003: 68). How successful this may be clearly depends on the viewer, but even in the more ethereal dream sequences, the shear physicality of the shots, whether it be the detailed texture of the landscape or the bare

Figure 3.14: Ivan and the earth: first dream.
Still from *Ivan's Childhood*.

skin of the children's bodies, is nearly as prominent as elsewhere in Tarkovsky's work.

But it is also here that Deleuze, for all of the regard he shows Tarkovsky's theoretical writings, seems to most miss the mark on the films themselves, believing that in the material weight of the films the invisible force of time is 'frozen in these sodden, washed and heavily translucent images' (Deleuze 1989: 75). In fact, it is precisely through this wet, muddy and decaying world that the force of time most boldly emerges. Much as Bergson, in *Creative Evolution*, draws attention to the way in which duration 'marks the living being with its imprint' Tarkovsky's

incongruous absorption in the physical, conveyed through water, earth or flesh, is here a necessary component of the invisible processes the films seek to capture (Bergson 1998: 37). The physical world we encounter through our senses (even in the form of an image on the screen) functions as the entranceway to the virtual (memories and dreams) or, perhaps more concisely, eternity opens through the material reality of the present moment. This, in turn, illuminates the subdued, yet omnipresent feature of Tarkovsky's aesthetic mentioned above: the attempt to diagram the horizon of the material and the spiritual, often through the disruptive force of time and the fluctuating distinction of perception and memory. While in the later films this may be accomplished more often with the long, disorienting tracking shots and the spatiotemporal anomalies which so often accompany them, *Ivan's Childhood* is primarily focused on the fissure between the present and the past, reality and fantasy. The river, the surface of the swamp as well as other reflective pools and translucent surfaces all function according to the pattern of the mirror which, in this respect, occupies the most conspicuous place within a range of images and motifs delineated and traversed at various stages of the film.

In this way, rather than remaining within the static distinctions the film initially appears to set forth, and which come to form the various reflective facets of its crystalline structure, *Ivan's Childhood* instead uses these facets as the means to express (somewhat

paradoxically) convergence and interpenetration, not unlike what Schelling describes the 'circulation between the corporeal and the spiritual, upon which human wit is so often exercised' (2000: 62). Perhaps what Žižek glimpses in the physicality of Tarkovsky's work may be productively considered a variation on Schelling's notion of 'one and the same substance' (Schelling 2000: 62), as the film attempts to trace the extension of the finite into the Absolute, describing a line from the physical actuality of the present moment to the virtuality of the past. Much as Merleau-Ponty described Bergson's relationship to Schelling, in Tarkovsky's work the 'recourse to temporality' is the means of bringing out 'the eternal within the finite' (Merleau-Ponty 2003: 48; Tarkovsky 1986: 37).

But while this comparison is compelling, some of the later work of Merleau-Ponty may offer a more directly relevant and illuminating contemporary perspective for approaching the film, and at the same time bolster the parallel. Though Tarkovsky almost certainly did not know his work, the seemingly self-contradictory concentration on the physical, which is paramount in the film-maker's metaphysical agenda, finds some revealing parallels in Merleau-Ponty's concept of the flesh (*chair*). As Natasha Synessios has suggested, the concept resonates, to varying degrees, in all of the films: 'Through time, space and the senses we can trace the flesh – as indivisibility, reversibility and chiasm – in different expressive modalities and diverse threads running through each of Tarkovsky's films and also

between films' (Synessios 2016: 75). In a quote that almost seems to be directed at the films, Deleuze and Felix Guatarri, in *What Is Philosophy?*, describe the flesh as 'both a pious and sensual notion, a mixture of sensuality and religion' (1994: 178). That such a concept would somehow coincide with Tarkovsky's 'cinematic materialism', at least on the surface would seem to be self-evident. However, though 'The intertwining – the chiasm' is one of the last complete chapters in Merleau-Ponty's unfinished and posthumously published *The Visible and the Invisible*, the concept remains ambiguous and its full meaning difficult to pin down with absolute precision. To a certain extent, this is by design; in its very nature, the flesh itself is resistant to firm determinations. As the 'formative medium of the object and the subject' it falls into neither category (Merleau-Ponty 1968: 147). Merleau-Ponty describes this less as a substance than 'an element, as the concrete emblem of a general manner of being' (1968: 147). In its reversibility, the flesh

is not matter. It is the coiling over of the visible upon the seeing body, of the tangible upon the touching body, which is attested in particular when the body sees itself, touches itself seeing and touching the things such that, simultaneously, *as* tangible it descends among them, *as* touching it dominates them all and draws this relationship and even this double relationship from itself, by dehiscence or fission of its own mass.

(Merleau-Ponty 1968: 146, original emphasis)

142

At this dynamic point of intertwining between what sees and what is seen, spirit and matter, the philosopher posits a chiasmic horizon, a reflective point between body and mind, visible and invisible. In notes from June 1960, for instance, Merleau-Ponty describes a dimensionality without space: 'There is a body of the mind, and a mind of the body, and a chiasm between them' (1968: 259). More explicitly, and especially pertinent to the matter at hand, 'the flesh *is a mirror phenomenon* and the mirror is an extension of my relation with my body' (Merleau-Ponty 1968: 255, original emphasis).

At this point, there is little need to further belabour the importance of the mirror to the structure and metaphysics of Tarkovsky's work, but a few final words may more neatly tie up the larger philosophical implications. In *Ivan's Childhood,* the fluid association of water and various reflective surfaces itself forms a remarkably precise analogue of this chiasm of matter and spirit. This is so not only in the more symbolic delineation of the living and the dead embodied by the river but also explicitly between the boy and himself, between his physical body and his consciousness of the world around him. A number of key episodes in the film even seem to add texture to Merleau-Ponty's challenging statements on the 'coiling over' of the sensible upon the sentient or the intertwining of the visible and the invisible. Ivan's second dream, as we have seen, begins with what initially seems a diegetically real close-up of Ivan's hand and then ascends,

without cutting, to the boy's oneiric double gazing down at a reflection of himself and his mother in the well. Ivan then stretches his hand directly through this reflection into the water and splits into yet another figure dipping his hands into the water at the bottom of the well. The sequence marks an especially moving and provocative demonstration of how the sensible body, even in the context of the dream, 'touches itself seeing'. When we consider how the mind thus figures in 'this double relationship from itself, by dehiscence or fission' (Merleau-Ponty 1968: 146), the sequence becomes especially emblematic of the various crossings-over we see throughout the film. Making relatively explicit the more implicit action of the later dreams, the boy actually penetrates the reflection, through himself seeing at the moment of the virtual/ actual divergence and breaking through the chiasm into a deeper layer of his mind.

That such a movement should occur within a dream is as characteristic of Tarkovsky's work as it is uniquely significant in this context. In *Ivan's Childhood*, as in the later films, dreams are frequently the pivotal structural events, where time and space fall from their expected patterns and open onto a more direct expression or sensation of reality unfolding. And yet this dream chiasm, seemingly the most subjective or individual experience possible, is always marked by the fluidity of its borders, to the point where the difference between dream and reality or memory and perception routinely lapses into indiscernibility.

As Merleau-Ponty wrote in his working notes to *The Visible and the Invisible*, 'the dream is inside in the sense that the internal double of the external sensible is *inside*' (1968: 262). Taken in this context, and given the reflective relationship of the dreams and the waking world established in the opening scenes, we may see more clearly how the film itself describes these sides of the chiasm: the dreams are the primary markers of the interstice – or perhaps more accurately, the interface – between the physical world and that of the mind and spirit. The dreams exist 'on the edge of being, neither in the for Itself, nor in the in Itself, at the joints, where the multiple entries of the world cross' (Merleau-Ponty 1968: 260). Ivan's waking dream then takes on additional significance as the most explicit point at which the distinction of matter and spirit drops away and physical reality is folded into memory and fantasy.

But even more illustrative of the film's idiosyncratic transcendentalism is the implication of Gal'tsev within this scheme and the attendant disintegration of hermetic subjectivity. If we take the numerous scenes where their perspectives overlap or seem superimposed, particularly within the context of Gal'tsev's last scene, we can deduce a coexistence of individual durations, moored in the consciousness of the character but gradually flowing out into the larger durational whole in which they meet. Not simply an implied invocation of the kinship between the two young soldiers, the graphic matches and fused

perspectives appearing throughout the film suggest the metaphysical doubling that is repeated throughout Tarkovsky's work and point to it as a vital aspect of the film-maker's attempt to evoke a sense of unity beneath the emergence of individual subjectivity - an intimation of the Absolute, to paraphrase the language of *Sculpting in Time*. Ultimately, in a profound variation of Ivanov's *proniknovenie*, Tarkovsky's focus on the horizon of matter and spirit is tightly coordinated with the gradual loosening of differentiated individuality and a more direct sense of intersubjectivity. The integration of Gal'tsev's gaze with that of Ivan, particularly in the closing sequences of the film when we learn that the boy is already dead, evokes more strongly the sense of 'an intercorporeal being' (Merleau-Ponty 1968: 143) running along the chiasm: 'For, as overlapping and fission, identity and difference, it brings to birth a ray of natural light that illuminates all flesh and not only my own' (Merleau-Ponty 1968: 142).

4
Reception in the Soviet Union and Abroad

The Soviet reaction

The premiere of *Ivan's Childhood* in the spring of 1962, as Maya Turovskaya attests, was immediately received as a work powerfully disorienting in its novelty:

> Two hours later we emerged from the small viewing theater baffled and curious, not knowing whether to criticize the author of the film for our confusion or whether to set aside our usual criteria and surrender ourselves to the strange world that had flickered for a short while on the screen before us.
>
> (1989: 1)

The lack of controversy in the Soviet Union and a largely enthusiastic reception abroad make *Ivan's Childhood* rather unique among Tarkovsky's work. Its reception in official circles and the Soviet press was warmer than any enjoyed by the later films, with reviews often heralding the film-maker as a remarkable new talent. The prediction of a distinguished career is particularly strong in a write-up for the government newspaper *Izvestiia* from 25 May 1962 by the poet Konstantin Simonov, one of the official intellectual

leaders of the wartime generation. Following what seems to be the general line, his article is not so much a review of the film but rather a tempered, albeit positive appraisal which immediately acknowledges the talent of the young film-maker and promises to follow the rest of his career closely. Though certain aspects of the article smack of officialdom, Simonov enthusiastically recognized the poetic nature of the film and actually labels it a *'poema'*, no small compliment from the author of 'Wait for Me' (1941), one of the most popular poems of the war. The observation was also prescient, as *Ivan's Childhood* became perhaps the seminal work of Soviet 'poetic cinema'. Rather than discuss the film as a typical adaptation, Simonov sees it more as a kind of translation from prose to poetry: 'In his story Bogomolov saw the war through the precise and narrow gaze of a prosaist. Tarkovsky read his story with the eyes of a poet. And [...] in the language of cine-poetry, wrote a tragic poem on the mutilation of *Ivan's Childhood* for the screen' (Simonov 1962). But at the same time, he adopts the patronizing tone of a wiser, Stalin-era artist offering instruction to a member of the younger generation. Though he is effuse in his praise of the young director, he also sees him as unjustifiably lacking in self-confidence, something which was indeed echoed in Tarkovsky's later comments on the film as a kind of experiment to see what he could do as a film-maker. Simonov and Tarkovsky were agreed in another area as well: both disliked the scene in which Ivan encounters an old

man sifting through the remains of his house. Simonov's commendation of the film's symbolism, on the other hand, comes across as rather ambiguous and very much at odds with the director's rejection of any such techniques in his work. While there is certainly much in this film that may be considered symbolic, in most cases these are not the most interesting aspects of its aesthetic strategy. Due to its placement in the article, one suspects that perhaps this vague acclaim is included to set the stage for Simonov's strong disapproval of the film's shifting of Bogomolov's principle setting to the ruined church, something he feels adds nothing the film's quality and even detracts from the otherwise excellent depiction of Ivan. Ultimately Simonov sees these as forgivable defects and in no way caused by the inadequacies of Tarkovsky's artistic talent. Rather, 'they are essentially the result of the artist's lack of confidence in himself' (Simonov 1962). It is not surprising that an official Soviet artist would find fault with the work's openly spiritual overtones, but the criticism still seems unwarranted: Simonov (1962) notes a 'cheap effect' in some of the film's most powerfully resonant images and associations.

Maya Turovskaya's review in *Literaturnaia gazeta* ('Literary gazette')[12] and Neia Zorkaia's extensive reaction in the leading Soviet cinema journal, *Iskusstvo kino* ('Art of cinema') harboured no such reservations. Echoing Simonov, both see the film as a strong departure from the more conventional cinema of the recent past and both recognize Ivan as a novel

figure in Soviet war films, one who embodies the outlook and often trauma of the now mature members of his generation. As Zorkaia put it, 'in *Ivan's Childhood* today's 25 and 30-year-olds reveal their own truth about the war to us' (1962: 105). Although both reviewers had come into adulthood during the war, they are far more sympathetic to the views of Tarkovsky's (and Ivan's) generation than the older Simonov. Both of them also make the shift in perspective from Gal'tsev in Bogomolov's tale, to Ivan in Tarkovsky's adaptation, a point of emphasis. Unlike Simonov, both are quick to note the split realities of the war and the dreams. Zorkaia in particular emphasizes this point, citing the opposition between Ivan's life as it should be and his life as it is in the war as a reflection of the film's primary theme: the unnatural distortion and destruction of his psyche. The film's two narrative planes emerge from a 'distorted, disfigured nature': 'the life which should be and the one which has no right to exist' (Zorkaia 1962: 108).

Turovskaya's commentary rests on a similar dichotomy, actually taking this as its title, 'A world cleft in two' ('Mir raskolotyi nadvoe'), and it is perhaps the most insightful early description of the film. Most informative, for a contemporary perspective, is the novelty Turovskaya finds in Tarkovsky's description of the war. Many decades and hundreds of films later, this is something easily lost on most of today's viewers, but critical for an understanding of the world in which this film was made. One of the first things

Turovskaya notes is that Tarkovsky does not make a 'prose' film but takes a 'diametrically opposite point of view' from that of Bogomolov, one that reflects the emergence of Ivan's (and Tarkovsky's) generation as a new and compelling perspective on the war:

> The important thing is that after so many war films, one should be produced in 1962 by a director from Ivan's own generation, and that it should be so different from the tradition of war films from which it springs.
>
> (Turovskaya 1989: 2)

The difference, as Turovskaya sees it, also penetrates deeply into the diegesis of the film. In comparison to the adults around him, Ivan has a qualitatively different reaction to the war, an 'emotional dislocation, and it is this which creates a subtle barrier between Ivan and the adults fighting the war' (Turovskaya 1989: 6). This generation gap is again reflected in the reception of the film. The change of setting from a dugout to an abandoned church, which so dismayed Simonov, is here seen as a natural progression: 'For Tarkovsky, the choice of a ruined church, with a bell still in one piece where it fell on the floor, is no mere whim. Nor should it be interpreted as part of the fashionable Russian religious revival' (Turovskaya 1989: 4).

Turovskaya also possesses a keen eye for the repetition of similar images across the film. In addition to noting the empty coat that haunts Ivan's waking dream and the newsreel footage of Berlin, she notes the linked images of the dream sequences,

151

culminating in a compelling, if somewhat vague, reading of the final sequence. This last dream

> is not merely allegorical, but is an expression of the depth of a need, which grows out of the heart of the film, out of its dislocated imagery. This final sequence is far more than a 'moral' put forward as an 'afterword' by Tarkovsky to cap Ivan's crippled and extinguished childhood. It is an effort of the will, reaching out towards the harmony and wholeness of an ideal for humanity.
>
> (Turovskaya 1989: 10)

It may not be an especially close reading, but Turovskaya actually gets to the core of *Ivan's Childhood* and each of the six films that would follow. Amidst the atrocities of the war and the shattered reality before Ivan, there emerges an unmistakable yearning for some kind of transcendence. As she puts, 'from absolute disharmony is born the dream of absolute harmony' (Turovskaya 1989: 9).

Venice Film Festival

While it received a warm reception from most quarters in the Soviet Union, it was the success of *Ivan's Childhood* at the Venice Film Festival which truly established Tarkovsky as a leading figure in Soviet cinema. From any perspective, winning a share of the Golden Lion at Venice was one of the great popular and critical triumphs of Tarkovsky's career. While festivals and competitions are not necessarily reliable measures of artistic merit, the fact that a Soviet

film from a completely unknown director shared the Golden Lion with the more established Valerio Zurlini's *Family Diary*, a film which starred the legendary Italian actor Marcello Mastroianni (who had already played the lead in films by Michelangelo Antonioni, Luchino Visconti and Federico Fellini), gives some indication of the impression the film must have made at the time. Though the selection of works shown in competition and those awarded the Golden Lion was sometimes uneven, there was no shortage of serious works in the Venice competition. The previous year, the Golden Lion went to Alain Resnais' astonishing *L'année dernière à Marienbad* (*Last Year in Marienbad*) and throughout the 1960s the festival screened numerous classics from directors like Visconti, Akira Kurosawa, Luis Buñuel, Robert Bresson, John Cassavetes, Vittorio De Sica and Andrzej Wajda. In addition to Zurlini's work, the competition in 1962 included Stanley Kubrick's *Lolita*, Pier-Paolo Pasolini's *Mama Roma*, John Frankenheimer's *Birdman of Alcatraz* and Jean-Luc Godard's *Vivre sa vie* (*My Life to Live*). *Ivan's Childhood* was actually the second film in competition from the Soviet Union that year, screening a few days after Sergei Gerasimov's *Liudi i zveri* (*Men and Beasts*), but it was the first ever to win.

Even so, it did not strike everyone in the Venice audience equally. The film, as we shall see in more detail, left some Italian leftists wanting a more political angle. Even Edith Laurie in her notes for *Film*

Comment found *Ivan's Childhood* lagging behind God-ard's entry, describing it as 'TOO poetic' with 'a few touches of expressionism and labored lyric fantasy' (Laurie 1962). Nevertheless, she concluded that 'Tarkovsky is talented and his tale of a twelve-year-old patriot, whose childhood was lost in the war, has deeply moving moments' (Laurie 1962). Clearly, the reservations expressed by Laurie and some members of the Italian left were not widespread. And given the extremely emotional hometown reception report-edly received by Zurlini's film, which was based on a beloved novel by the Italian writer Vasco Pratolini, sharing the Golden Lion was a major achievement for both Tarkovsky and Soviet cinema as a whole.

Jean-Paul Sartre

Zorkaia and Turovskaya set the standard for a serious consideration of Tarkovsky's work. But undoubtedly the most consequential early reaction to *Ivan's Child-hood* is that of Jean-Paul Sartre. His remarkable letter to Mario Alicata, the editor of the Italian Communist Party's official newspaper *L'Unità* has become a cor-nerstone of the Tarkovsky legend. The letter, though it contains several flaws in its reading of the film, remains the most important early evaluation of Tark-ovsky's work and certainly played no small part in the film's enthusiastic reception outside of the Soviet Union. It was written in the wake of the film's success in Venice, but Sartre had actually seen the film several months earlier in Moscow. While there are references

to the negative criticism it received from write-ups in the Italian papers *Il Paese* and *Paese sera*, Sartre's reaction seems to be directed primarily at Ugo Casiraghi, who had been covering the Venice Film Festival for *L'Unità* (1962).

Casiraghi's review of the film, which appeared on 6 September 1962, is clearly oblivious to much of its depth, but perhaps not as negative as Sartre's reaction suggests. In fact, Casiraghi recognizes quite correctly that the tension between the reality of the war and the lost childhood of the dreams is a 'dominant lyrical motif' (1962), and praises the depiction of Ivan as a precocious commander. And yet, despite the fact that he, unlike Sartre, was a professional film critic, the review remains unduly dismissive of the 'poetry' so highly regarded by the Soviet critics, even attacking the filmic structure as 'elementary' and populated with 'calligraphic language' (Casiraghi 1962). He recognizes the work as an improvement over Vasilii Pronin's *Son of the Regiment* (something few film-goers could fail to miss), but declares a baffling preference for the work of Sergei Gerasimov, whose *Men and Beasts* was also in the competition. One of the most interesting aspects of Casiraghi's review is that it calls out Sartre himself, dismissing the philosopher's praise for the film's stylistic structure.

Sartre's letter to Alicata, which was also published in October 1962, is not a point by point response to the criticism *Ivan's Childhood* aroused in certain circles, but it does take up many of the issues it seems

155

to have raised. In his outline of the main character, Sartre largely seems to agree with Casiraghi's description, and like him makes a comparison with an earlier Soviet work. In this case, it is Sergei Bondarchuk's *The Fate of a Man*, an adaptation of a story by Mikhail Sholokhov, whose epic novel *The Quiet Don* would won him the Nobel Prize in 1965. *The Fate of a Man* was adapted for the screen in 1959 and quickly became one of the classic films of the Thaw, undoubtedly exercising some influence on Tarkovsky as a film student. Sartre's reference is to the war orphan Vania, adopted by the main character at the conclusion of the film. The scene is one of the most moving in Bondarchuk's highly emotional film, where the hero Sokolov actually lies to the boy by claiming to be his lost father. As Sartre points out, however, such a denouement was an impossibility in the Soviet tragedy of *Ivan's Childhood*: this frank expression of a world thrown out of balance by the war can only end in death and destruction.

At the centre of this work 'about the total losses of history' (Sartre 2008: 45), Sartre sees Ivan as a more realistic contrast to the positive heroes of the past, a character brutally torn apart by the unnatural forces at play around him. In this reading, the boy teeters on the edge of insanity and suicide, so dead inside that he now 'wages war for the sake of war' from a position of absolute isolation (2008: 42). Sartre compares Ivan to young Algerians he had encountered during the war for independence from France,

which had ended only a few months previously. Like them, Ivan lives on a different plane; there is 'no difference between the nightmare of their waking state and their nocturnal nightmares' (Sartre 2008: 38). Unlike the Italian reviewers, Sartre sees the character as striking a universal chord. More shrewdly, he posits that the reason we see Ivan's mother die in different ways in the boy's early dreams is because the traumatic event has entrenched itself so firmly within the boy's psyche that it is now 'too deeply submerged' to reappear in anything but a heavily adulterated form (Sartre 2008: 39). It is in this astute examination of the hero's psychological complexity that Sartre most pointedly takes issue with what he calls the 'simplistic vision' of the critics (2008: 36). While Casiraghi had indeed called the expressionism of the dreams themselves simplistic, Sartre sees them as far more than simple lyrical interludes. Rather, he describes them as both controlled and necessary elements of the story, components of a 'narrative method demanded by the subject itself' (Sartre 2008: 39). As we have already seen, the links between the story and its structure are indeed critically intertwined and the analysis of the film in the previous pages is undoubtedly influenced by Sartre's early intuition in this regard.

Declaring it a Soviet counterpoint to François Truffaut's *Les Quatre Cents Coups* (*400 Blows,* 1959), he finds the film to be both quintessentially Russian and completely original, created by an auteur who

combines the rhythm of Godard and the 'protoplas-
mic slowness' of Antonioni (Sartre 2008: 45), while
clearly being inspired by neither. Though Tarkovsky
had already begun to establish his own aesthetic path
as early as *The Steamroller and the Violin*, it seems
unlikely that he was as out of touch with western
cinema as Sartre claims. And by 1962, both Anto-
nioni and Godard had already established them-
selves as two of the most exciting and well-known
film-makers in the world. It is a minor point, to be
sure, but Sartre's trenchant evaluation of the film is
unfortunately beset by similarly paltry, though nag-
ging issues. At a glance, the most obvious of these
is the misrepresentation of Tarkovsky's age. Sartre
makes the same mistake as Simonov and insists that
the film-maker was 28 at the time, not 30, as Casir-
aghi had correctly reported in his summary of the
Venice festival. Despite having the full attention of
his translator, Lena Zonina, this – as well as some
other details regarding the film and its creator – may
not have crossed the language barrier; Sartre clearly
misses the fact that Kholin has been killed by the
end of the film and he does not seem to have noticed
Ivan's obvious affection for Kholin and Katasonych.
For the former misunderstanding, one may specu-
late that this is the result of a poor translation, but
the latter seems to point to something missing in the
reading of the film itself. As so many other observa-
tions are accurate, the most likely reason for such
discrepancies seems to be the fact that Sartre had

seen it in Moscow months previously, presumably without adequate dubbing or subtitles.

Yet this does not quite explain his somewhat strange insistence that the dreams in the film are 'perfectly objective' (Sartre 2008: 39), a view seemingly opposed to that of Turovskaya. Sartre insists that since we see Ivan in his dreams, they are not subjective in a sense that would have been objectionable to Casiraghi or the other Italian leftists who had criticized the film. On the surface, this seems to contradict his more incisive assertions about the film as a reflection of Ivan's psyche, and in particular the appropriateness of the film's poetic form to its content. Unwittingly perhaps, this apparent paradox points to vital stylistic and philosophical tendencies that pervade the director's work. As we have seen in the deeper analysis of the film's structure, the subjective/objective distinction is one of its most important characteristics; in Ivan, as we see him in the dreams as well as in his relations with the other characters, perspective plays an unusually critical role. Sartre's emphasis on the honest complexity of Ivan illuminates some of the more difficult and often troubling aspects of this film, but he is only able to scratch the surface of its stylistic dimensions, which provide a fuller picture of what is taking place within the character. While the evaluation Sartre provides of Ivan's psychological make-up is insightful and provocative, in the end, it is most effective in its suggestion that there is far more lurking within.

Conclusion

The transcendental nature of Tarkovsky's work is often determined by a similar interdependence of identity. In this sense, and repeatedly from *Ivan's Childhood* to *Sacrifice*, intimations of the Absolute emerge most often within the sphere of human relationships, rather than isolated revelations; they unfold in the recognition of the other not just as another subject, to modify Ivanov's phrase, but rather an extension of the same subject. The parallels to Merleau-Ponty's notion of the flesh, though hardly perfect, nevertheless help describe the primordial, pre-objective sensation of being the film strives to communicate in its most intense sequences, and the common foundation hidden beneath the differentiation of subject and object, which begins to surface here in the meticulously crafted ambiguity of the final moments. As the film pushes us to reconsider our perspective on reality, with greater attention to the flux of time and the inner workings of consciousness, the initial juxtaposition of characters yields to an increased awareness of shared identity and experience, the incompleteness of the individual 'I'.

This current, initiated so powerfully in *Ivan's Childhood*, runs through all of Tarkovsky's films, emerging perhaps most explicitly in *Nostalghia* with Domenico's

formula of $1 + 1 = 1$.[13] It is perhaps in this sense that the significance of time in Tarkovsky's work, despite manifest similarities, departs somewhat from thinkers like Deleuze and becomes a primary means of relating this underlying unity. As Thomas Aquinas (1225–74) described the soul, resting '*on the horizon of eternity, and time*', the time-image in Tarkovsky's work describes a similar liminality (Aquinas 1975: 265, original emphasis). The characters of these films, and Ivan in particular, find themselves 'situated on the boundary line between corporeal and incorporeal substances' (Aquinas 1975: 265), but it is a line which opens out to those around them, as the image of time, to again quote Bergson, 'excludes all idea of juxtaposition, reciprocal externality, and extension' (1998: 26). As is often the case, and particularly so here, this prevailing, if understated concentration on the intersection of actual and virtual is tightly interwoven with a bold cinematic articulation of consciousness.

Despite its relative immaturity, this is where *Ivan's Childhood* set the standard for the films that would follow. Perhaps nowhere in the director's work is the tension, what Stalker calls the 'friction between the soul and the outside world', as jarring as the dreams and waking reality experienced by Ivan. While there is much in this film which, by design, resists definitive interpretation (and the preceding pages in no way offer the sole means of approach), it nevertheless articulates a powerfully direct address to the human condition. As Tarkovsky would later write:

Again and again man correlates himself with the world, racked with longing to acquire, and become one with, the ideal which lies outside himself, which he apprehends as some kind of intuitively sensed first principle. The unattainability of that becoming one, the inadequacy of his own 'I', is the perpetual source of man's dissatisfaction and pain.

(1986: 37)

While few works in any medium express this ontological 'dissatisfaction and pain' so movingly, even fewer create such a profound, if fleeting sense of the intrinsic, yet seemingly unattainable first principle connecting individuals.

Notes

1. For an excellent overview of the depiction of children in Soviet cinema at the time *Ivan's Childhood* was made, see Alexander Prokhorov's article 'The adolescent and the child in the cinema of the Thaw' (2007). A larger overview of children in Soviet cinema is provided in Evgenii Margolit's 'Prizrak svobody: Strana detei' (2002); unfortunately, it remains untranslated.

2. While the film does get comparatively short shrift in larger studies of Tarkovsky, a notable exception is a concise history and critique by Robert Bird (2008: 29–36).

3. For a more in-depth study of time and perspective in this film, see 'Deleuze on Tarkovsky: The crystal-image of time in *Steamroller and Violin*' (Efird 2014).

4. Tarkovsky was hardly Iusov's only regular collaborator. The cinematographer worked several times with such noteworthy film-makers as Georgii Daneliia, whose *Ia shagaiu po Moskve* (*Walking the Streets of Moscow*, 1964) is another of the undisputed classics of Soviet cinema of the 1960s. He also made three films with Sergei Bondarchuk, including the brilliantly realized *Oni srazhalis' za rodinu* (*They Fought for the Motherland*, 1975). In addition, he worked successfully with Nikita

Mikhalkov in *Anna ot 6 do 18* (*Anna: From Six to Eighteen*, 1993) and made several films with Ivan Dykhovichnyi. In the 1980s, he also began working as a professor at the Film Institute VGIK.

5. Altogether he appeared in dozens of films, often in lead roles, such as Aleksei Batalov's adaptation of Dostoevskii's *Igrok* (*The Gambler*, 1972) and *Lermontov*, which Burliaev himself wrote and directed. Perhaps his most memorable roles (other than those in which he worked with Tarkovsky) are considerably smaller. He has a classic and unexpectedly brief part in Evgenii Karelov's *Sluzhili dva tovarishcha* (*Two Comrades Served*, 1968); and a supporting role as a young Nazi collaborator in Aleksei Iu. German's classic *Proverka na dorogakh* (*Trial on the Road*, 1971), another film which endured a long sentence in the film vaults.

6. She was born into the family of a Soviet general and, in addition to Tarkovsky, was romantically linked to a number of well-known Russian actors, including Aleksandr Kaidanovskii, the star of *Stalker*. Though she did go on have a more extensive career in film and on stage, it was interrupted in 1983 when she was imprisoned for the murder five years earlier of the actor Stanislav Zhdanko, with whom she had been living at the time. Upon her release in 1988 (she steadfastly maintained her innocence throughout), she performed again to a limited extent, but an accident in 2001 took her eyesight and effectively ended her career.

7. Zubkov served as a pilot before being discharged with tuberculosis. *Ivan's Childhood* is perhaps the role for which he is best known, but he had compiled a thick resume in other outstanding films by the time of his death in 1979. Among his more notable films are Iulii Raizman's *Kommunist* (*The Communist*, 1959) and Iosif Kheifits' *Den' schastia* (*Day of Happiness*, 1964).

8. Grin'ko's work stretched far beyond the films he made with Tarkovsky. He had an important role in Aleksandr Alov and Vladimir Naumov's vastly underappreciated *Mir vkhodiashchemu* (*Peace to Him Who Enters*, 1961) as a sympathetic American truck driver attempting to help a trio of Soviet soldiers in the last days of the war. Despite withering criticism at home, the film was the Soviet Union's entry for the Venice festival the year before *Ivan's Childhood*. Grin'ko also had roles in several other important films of the decade, including Sergei Parajanov's *Teni zabytykh predkov* (*Shadows of Forgotten Ancestors*, 1964) and Sergei Bondarchuk's *War and Peace*. In total, he appeared in over 100 films and worked almost right up until he death in 1989.

9. In later years, he described in gruesome detail many of these experiences, as well as how he had managed to rise to the position of company commander by the war's end – again accomplished with little significant formal training. Bogomolov was twice wounded during the fighting and

received several medals for bravery. His military career continued for seven years after the conclusion of the war. He finally retired from the service in 1952, shortly after having spent over a year in jail for, as he related in an autobiographical text, standing up to his superiors in defence of a fellow officer. There was never any formal trial and no official charges were made. See Bogomolov (2007: 728–30).

10. See the discussion of Simonov's critique in the final chapter of this book.

11. Joseph Goebbels (1897–1945), Reichsminister for Propaganda under Hitler, designated as Hitler's successor as Reichskanzler, an office he assumed for a single day following Hitler's suicide on 30 April 1945. He and his wife Magda committed suicide after poisoning their six children on 1 May 1945.

12. 'Mir raskolotyi nadvoe' was originally published in *Literaturnaia gazeta* and reprinted in translation as 'A world cleft in two' in Turovskaya 1989: pp. 2–11. Citations from this source.

13. A similar scene appears in Antonioni's *Red Desert* (1964), where two drops of oil ultimately form a single drop. The common thread, of course, is the screenwriter Tonino Guerra, who worked on both Antonioni's film and *Nostalghia*.

References

Aquinas, Thomas (1975), *Summa Contra Gentiles: Book 2: Creation* (trans. J. Anderson), Notre Dame: University of Notre Dame Press.

Bazin, André (2005), *What Is Cinema?* (trans. H. Gray), Berkeley: University of California Press.

Bergson, Henri (1920), *Mind Energy* (trans. H. Wildon Carr), Westport: Greenwood Press.

Bergson, Henri (1956), *Duration and Simultaneity* (trans. L. Jacobson), Indianapolis: Bobbs-Merrill.

Bergson, Henri (1991), *Matter and Memory* (trans. N. M. Paul and W. Scott Walker), New York: Zone Books.

Bergson, Henri (1998), *Creative Evolution* (trans. A. Mitchell), Moneola: Dover.

Bergson, Henri (2007), *An Introduction to Metaphysics* (trans. T. E. Hulme), Basingstoke: Palgrave Macmillan.

Bird, Robert (2008), *Andrei Tarkovsky: Elements of Cinema*, London: Reaktion.

Bogomolov, Vladimir (1987), *Ivan: A Story* (trans. B. Isaacs), Moscow: Raduga.

Bogomolov, Vladimir (2007), *Moment istiny (v avguste sorok chetvertogo)*, Ekaterinburg: U-Faktoriia.

Burliaev, Nikolai (1989), 'Odin iz vsekh – za vsekh – protivu vsekh', in M. Tarkovskaia (ed.), *O Tarkovskom*, Moscow: Progress, pp. 77–98.

Casiraghi, Ugo (1962), 'Gli allori de Festival all'Italia ed all'URSS', *L'Unita*, 6 September, p. 9.

Chatman, Seymour (1990), *Coming to Terms: The Rhetoric of Narrative in Fiction and Film*, Ithaca: Cornell University Press.

Deleuze, Gilles (1986), *Cinema 1: The Movement-Image* (trans. H. Tomlinson and B. Habberjam), Minneapolis: University of Minnesota Press.

Deleuze, Gilles (1989), *Cinema 2: The Time-Image* (trans. H. Tomlinson and R. Galeta), Minneapolis: University of Minnesota Press.

Deleuze, Gilles (1991), *Bergsonism* (trans. H. Tomlinson and B. Habberjam), New York: Zone Books.

Deleuze, Gilles and Guattari, Felix (1994), *What Is Philosophy?* (trans. H. Tomlinson and G. Burchell), New York: Columbia University Press.

Efird, Robert (2014), 'Deleuze on Tarkovsky: The crystal-image of time in *Steamroller and Violin*', *Slavic and East European Journal*, 58:2, pp. 237–54.

Evlampiev, Igor' (2001), *Khudozhestvennaia filosofiia Andreia Tarkovskogo*, St. Petersburg: Aleteia.

Filimonov, Viktor (2011), *Andrei Tarkovskii: Sny i iav' o dome*, Moscow: Molodaia gvardiia.

Florensky, Pavel (1996), *Iconostasis* (trans. D. Sheehan and O. Andrejev), Crestwood: St. Vladimir's Seminary Press.

Gianvito, John (ed.) (2006), *Andrei Tarkovsky: Interviews*, Jackson: University of Mississippi Press.

Green, Peter (1993), *Andrei Tarkovsky: The Winding Quest*, London: Macmillan.

Ivanov, Vyacheslav (1959), *Freedom and the Tragic Life: A Study in Dostoevsky* (trans. N. Cameron), New York: Noonday.

Johnson, Vida and Petrie, Graham (1994), *The Films of Andrei Tarkovsky: A Visual Fugue*, Bloomington: Indiana University Press.

Konchalovskii, Andrei (1989), 'Mne snitsia Andrei', in M. Tarkovskaia (ed.), *O Tarkovskom*, Moscow: Progress, pp. 224–37.

Kovács, András Bálint and Szilágyi, Ákos (1987), *Les Mondes d'Andrei Tarkovski* (trans. H. V. Charaire), Lausanne: L'Age d'Homme.

Laurie, Edith (1962), 'Notes from the Venice Film Festival', *Film Comment*, 1:3, https://www.filmcomment.com/article/notes-from-the-venice-film-festival/. Accessed 16 November 2020.

Lotman, Jurij and Uspenskij, Boris (1984), 'The role of dual models in the dynamics of Russian culture (up to the end of the eighteenth century)' (trans. N. F. C. Owen), in A. Shukman (ed.), *The Semiotics of Russian Culture*, Ann Arbor: Michigan Slavic Contributions, pp. 3–35.

Margolit, Evgenii (2002), 'Prizrak svobody: Strana detei', *Iskusstvo kino*, 8, pp. 78–85.

Merleau-Ponty, Maurice (1968), *The Visible and the Invisible* (trans. A. Lingis), Evanston: Northwestern University Press.

Merleau-Ponty, Maurice (2003), *Nature* (trans. R. Vallier), Evanston: Northwestern University Press.

Pearson, Keith Ansell (2002), *Philosophy and the Adventure of the Virtual: Bergson and the Time of Life*, London: Routledge.

Powell, Anna (2007), *Deleuze, Altered States and Film*, Edinburgh: Edinburgh University Press.

Prokhorov, Alexander (2007), 'The adolescent and the child in the cinema of the Thaw', *Studies in Russian and Soviet Cinema*, 1:2, pp. 115–29.

Salynskii, Dmitrii (2009), *Kinogermenevtika Tarkovskogo*, Moscow: Kvadriga.

Sartre, Jean-Paul (2008), 'Letter on the critique of *Ivan's Childhood*' (trans. J. Berenbeim), in N. Dunne (ed.), *Tarkovsky*, London: Black Dog Publishing, pp. 34–45.

Schelling, Friedrich Wilhelm Joseph (2000), *Ages of the World* (trans. J. Wirth), Albany: State University of New York.

Schelling, Friedrich Wilhelm Joseph (2006), *Philosophical Investigations into the Essence of Human Freedom* (trans. J. Love and J. Schmidt), Albany: State University of New York Press.

Schrader, Paul (2018), *Transcendental Style in Film: Ozu, Bresson, Dreyer*, Oakland: University of California Press.

Simonov, Konstantin (1962), 'Poema ob Ivanovom detstve', *Izvestiia*, 25 May, p. 6.

Skakov, Nariman (2012), *The Cinema of Tarkovsky: Labyrinths of Space and Time*, London: I.B. Tauris.

Smelkov, Iulii (1961), 'Katok i skripka', *Iskusstvo kino*, 8, pp. 25–26.

Soloviev, Vladimir (2003), *The Heart of Reality: Essays on Beauty, Love, and Ethics* (trans. V. Wozniuk), Notre Dame: University of Notre Dame Press.

Synessios, Natasha (2016), 'Andrei Tarkovsky – self, world, flesh', in N. Franz (ed.), *Andrej Tarkovskij: Klassiker – Классик – Classic – Classico*, Potsdam: Universitätsverlag Potsdam, pp. 65–83.

Tarkovsky, Andrei (1986), *Sculpting in Time: Reflections on the Cinema* (trans. Kitty Hunter-Blair), Austin: University of Texas Press.

Tarkovsky, Andrei (2003), *Collected Screenplays* (trans. W. Powell and N. Synessios), London: Faber & Faber.

Turovskaya, Maya (1989), *Tarkovsky: Cinema as Poetry* (trans. N. Ward), London: Faber & Faber.

Woll, Josephine (2000), *Real Images: Soviet Cinema and the Thaw*, London: I.B. Tauris.

Youngblood, Denise J. (2007), *Russian War Films: On the Cinema Front, 1914–2005*, Lawrence: University of Kansas Press.

Žižek, Slavoj (2007), 'The thing from inner space', in Renata Saleci (ed.), *Sexuation*, Durham and London: Duke University Press, pp. 216–59.

Zorkaia, Neia (1962), 'Chernoe derevo u reki', *Iskusstvo kino*, 7, pp. 103–08.